Dia De Los Muertos:

A Celebration Through Color

by:

Emelie Da Paixão & Chloe Alba

DIA DE LOS MUERTOS:
A CELEBRATION THROUGH COLOR

iUniverse books may be ordered through booksellers or by contacting:

iUniverse
1663 Liberty Drive
Bloomington, IN 47403
www.iuniverse.com
1-800-Authors (1-800-288-4677)

ISBN: 978-1-4917-7549-3 (sc)
ISBN: 978-1-4917-7548-6 (e)

Library of Congress Control Number: 2015915643

Print information available on the last page.

iUniverse rev. date: 09/24/2015

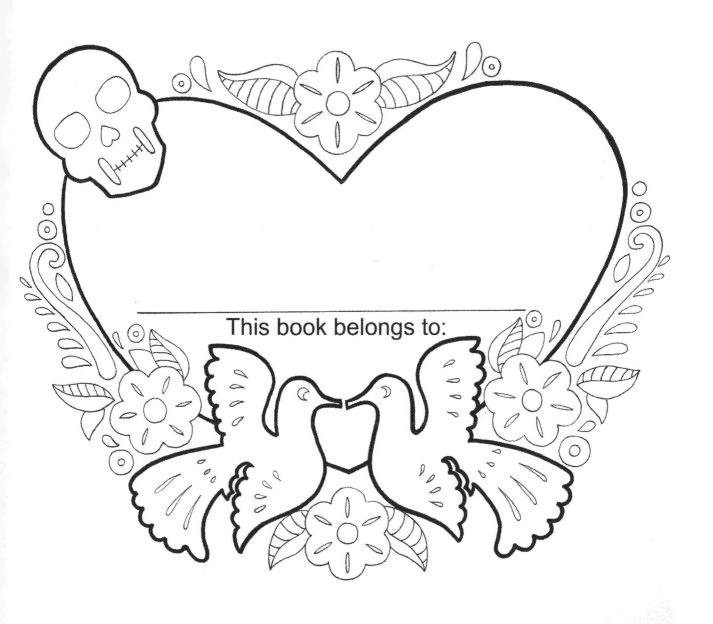

This book belongs to:

Many people around the world, even if they are not directly connected to Mexican culture, are drawn to the concept and imagery of Mexico's Day of the Dead. The holiday seems to continually gain in popularity as more people learn about it. Day of the Dead is primarily celebrated by Central America, South America, and the Catholic world. It occurs in the span of 2 days, beginning on November 1st, when it is believed all the angelitos (spirits of children lost) come to earth to be with their family. It ends on November 2nd, when it is believed the adult spirits come to celebrate life with family, festivities, and many traditional adornments. Dia de los Muertos dates back to pre-hispanic Aztec culture. For more than 500 years, the goddess Mictecacihuatl (Lady of the Dead) presided over Aztec harvest rituals which included fires and copal pom incense, costumes of animal skins, images of their dead and offerings of ceramics, personal goods, flowers, foods, and drink. People celebrate Dia de los Muertos to honor their deceased loved ones. The main celebrations consist of parades, ofrendas (altars for each relative), sweet breads, sugar skulls, and candles lit for each family member, an overall memorial of life in a positive light. In graveyards, families clean the graves of their loved ones, which they then decorate with flowers, photos, candles, foods and drinks. People stay up all night in the graveyards, socializing and telling stories of their ancestors. Musicians are hired to stroll through the cemetery, playing the favorite songs of the dead. Dia de los Muertos It is a loving ritual, full of joy and remembrance. The Day of the Dead is celebrated as a way of retaining connections with the unseen world — a world we will all return to one day.

Open this book and take a festive adventure into the world of Dia De Los Muertos; a world of happiness, color, and cultural tokens of what makes this tradition such a wonderful holiday. With each hand-drawn page for you to color, paint, and shade, the authors invite you to dive into their celebration of life. Ven con nosotros!

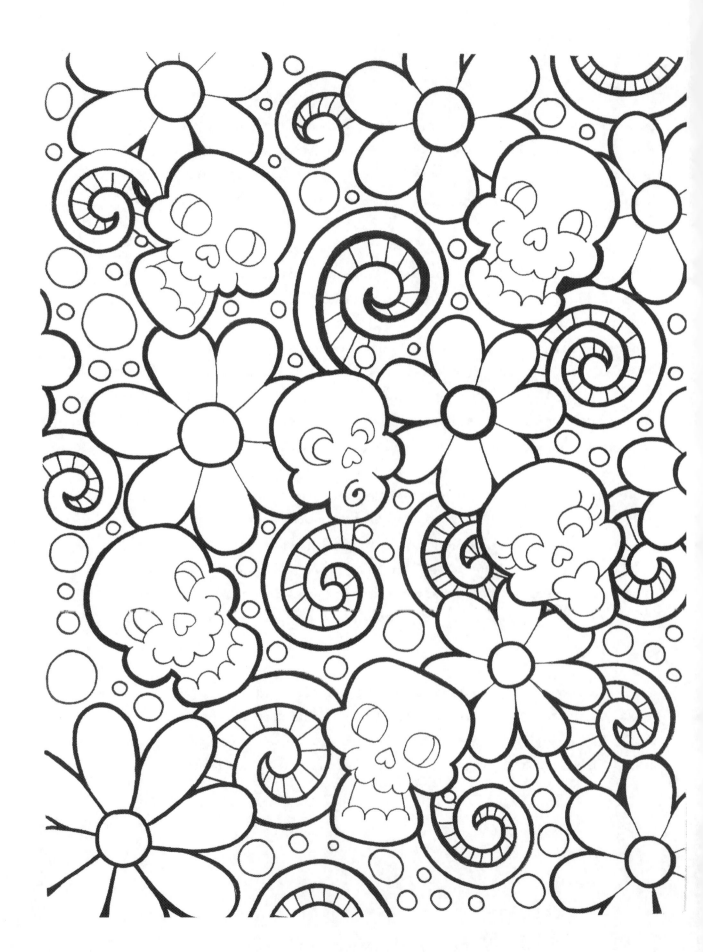

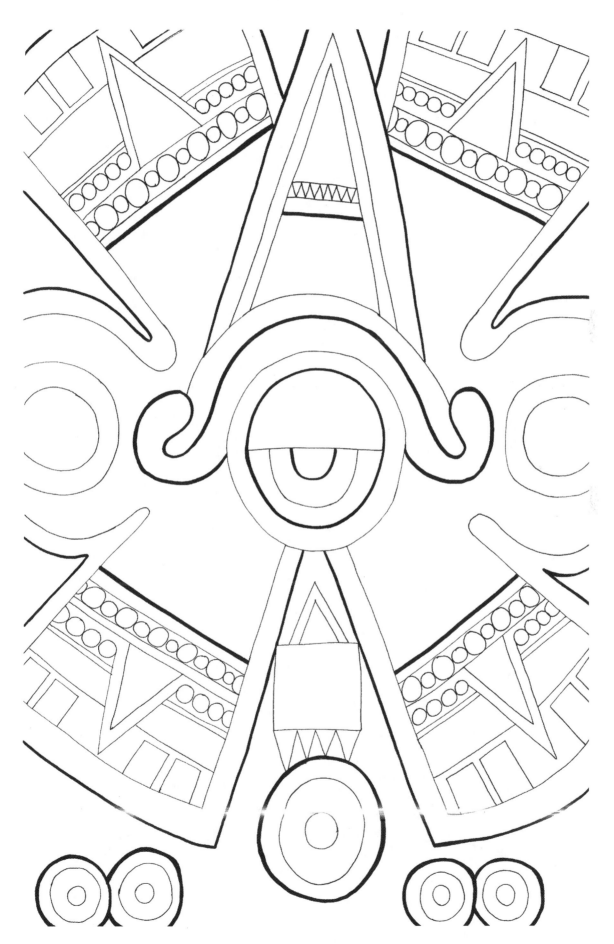

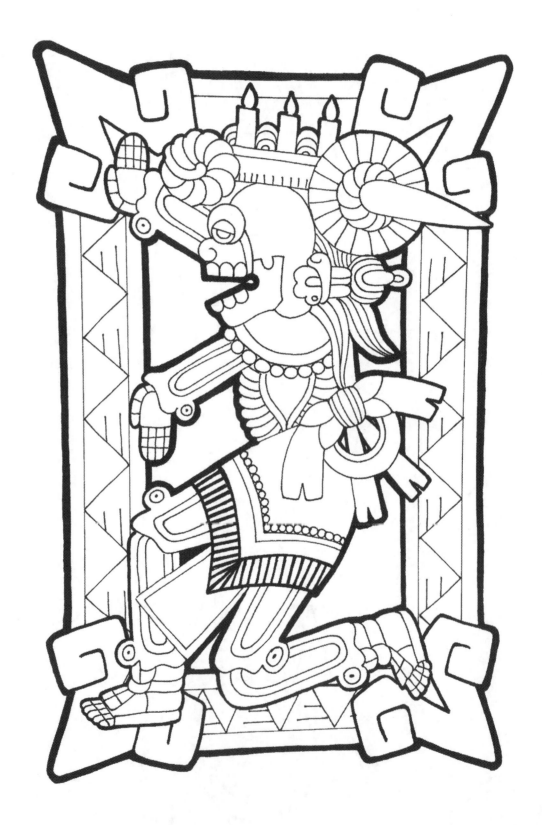

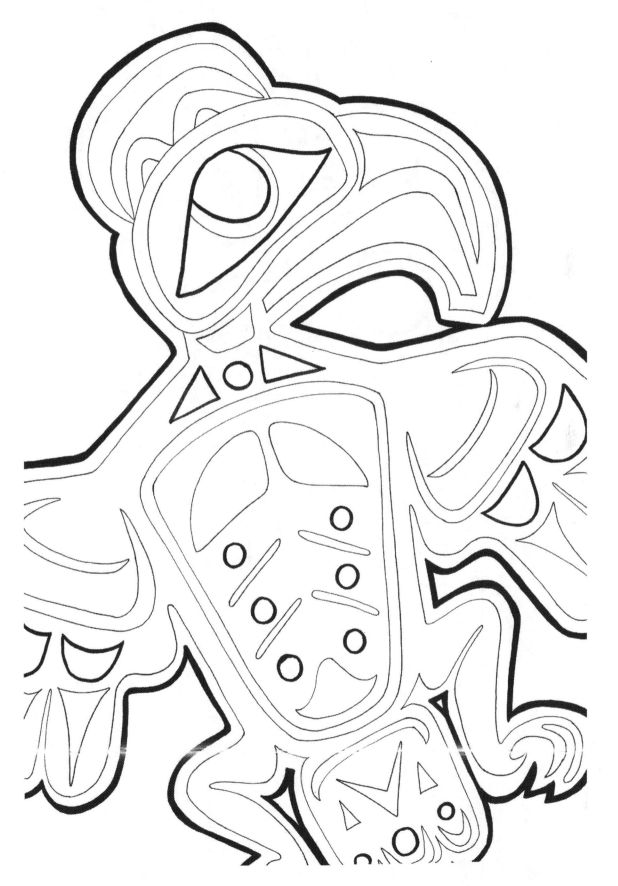

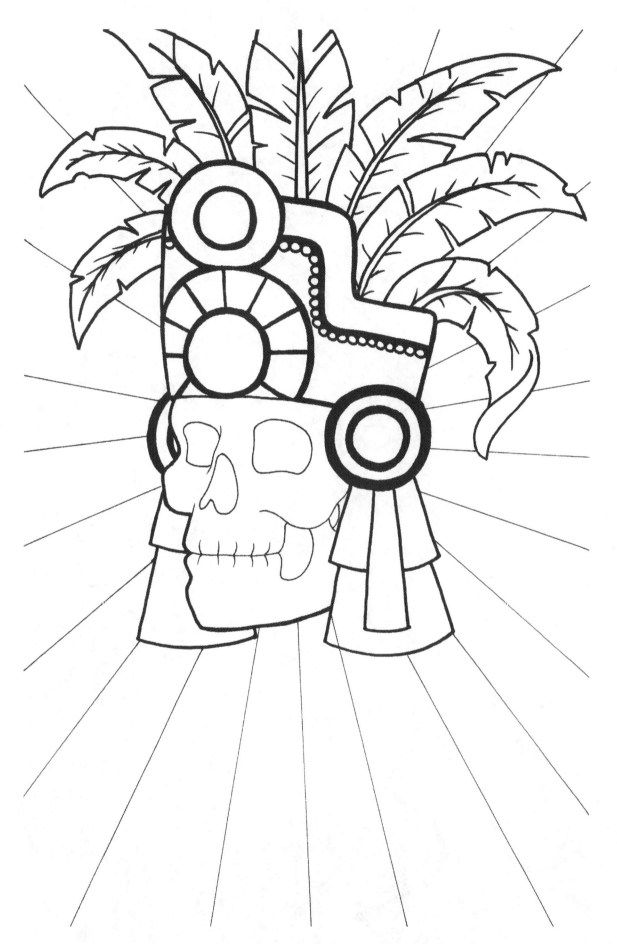

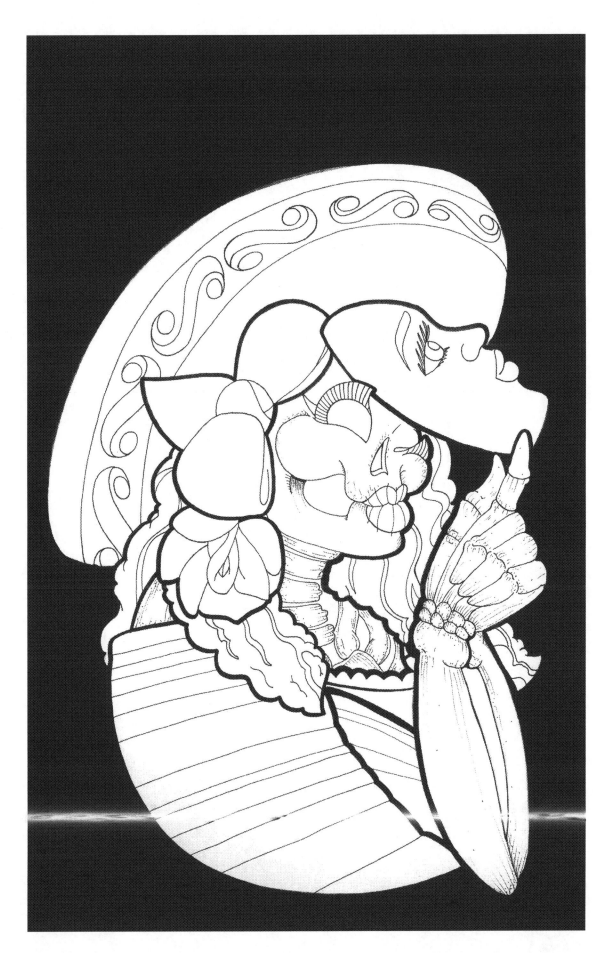

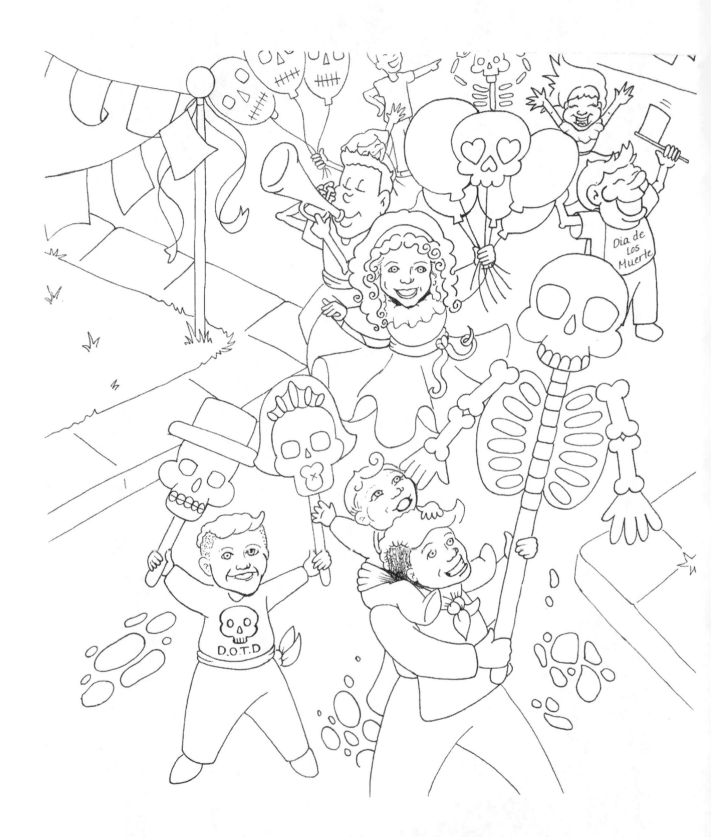

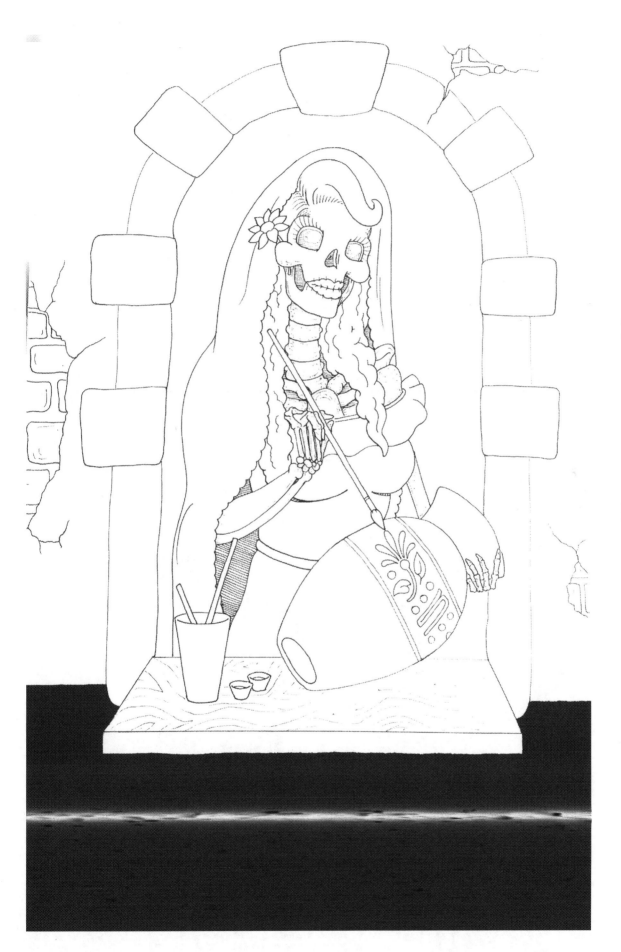

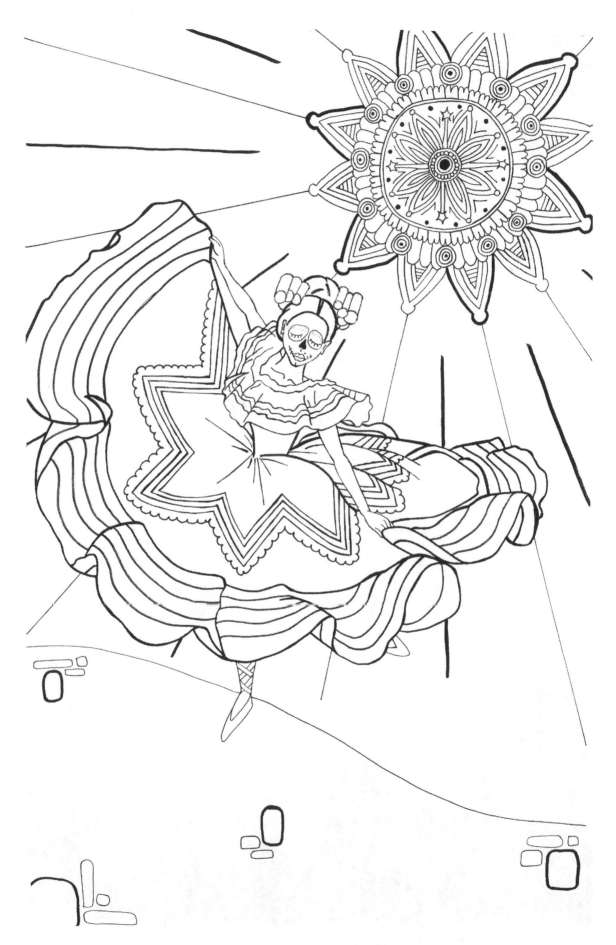

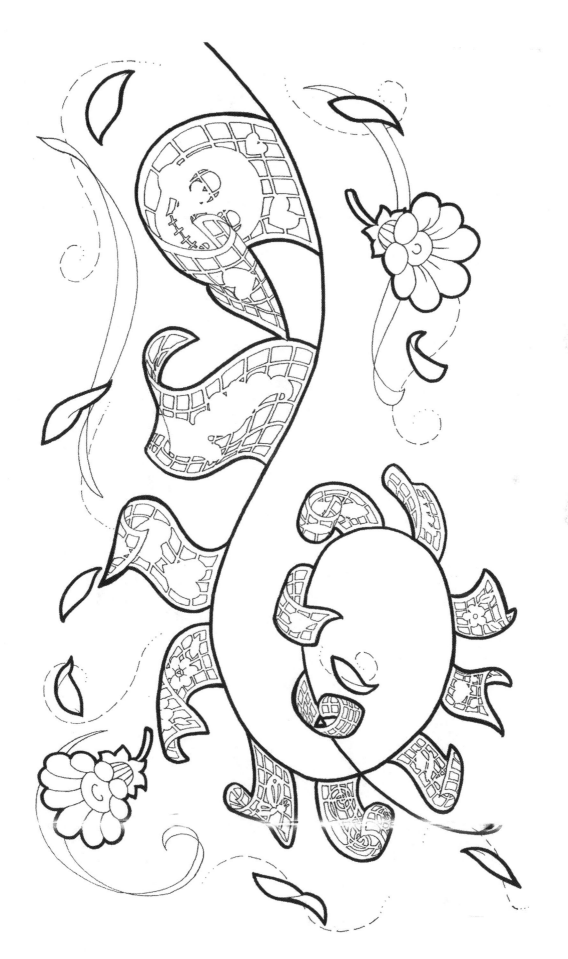

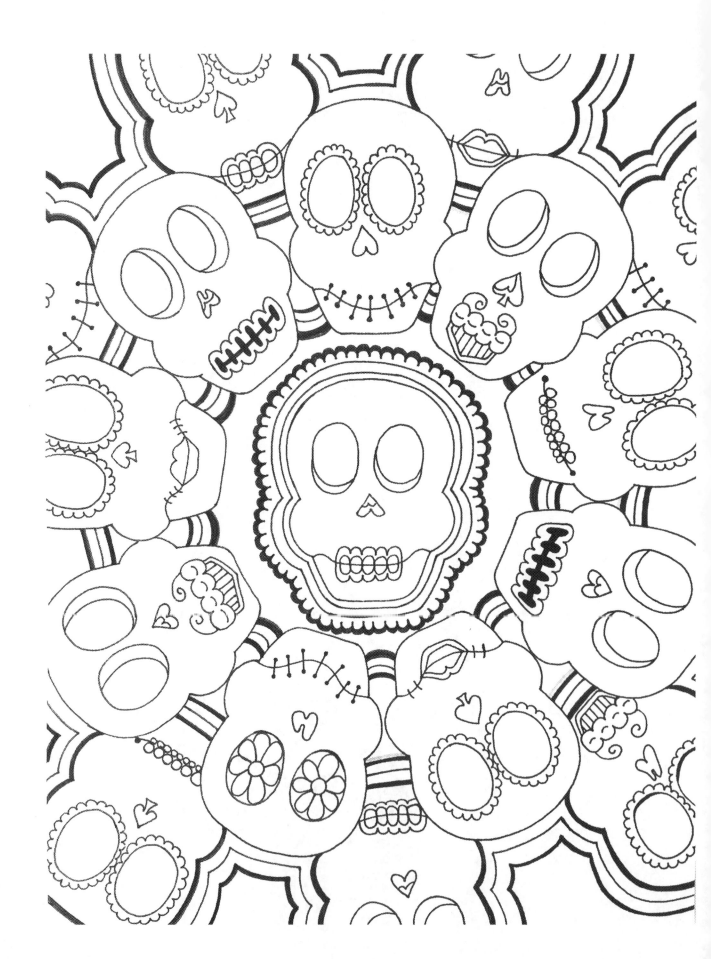

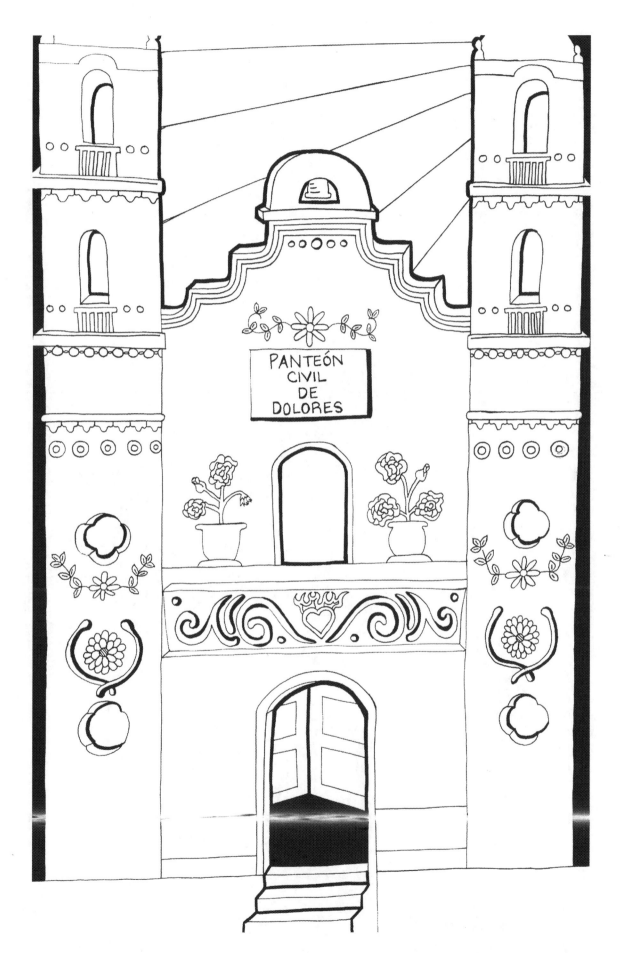

PANTEÓN
CIVIL
DE
DOLORES

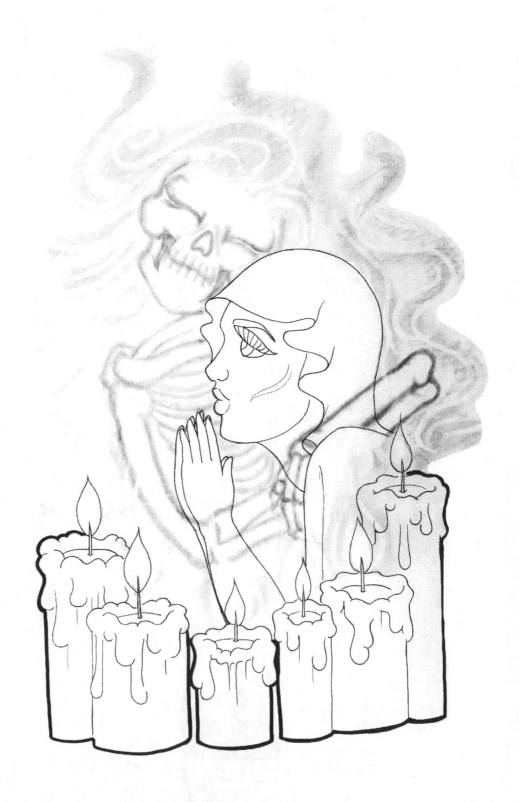

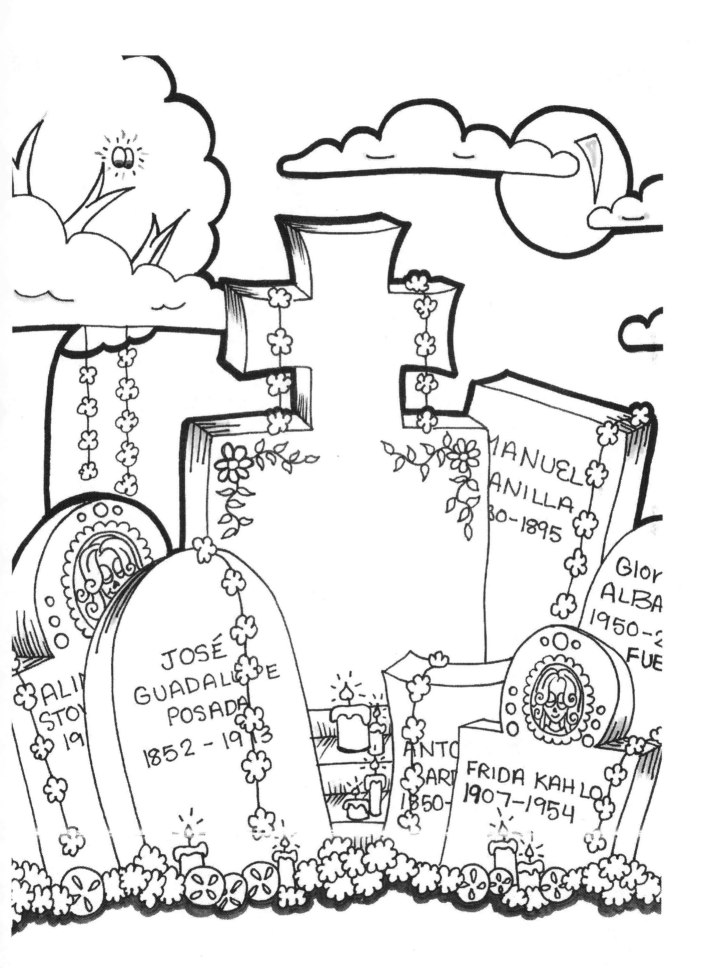

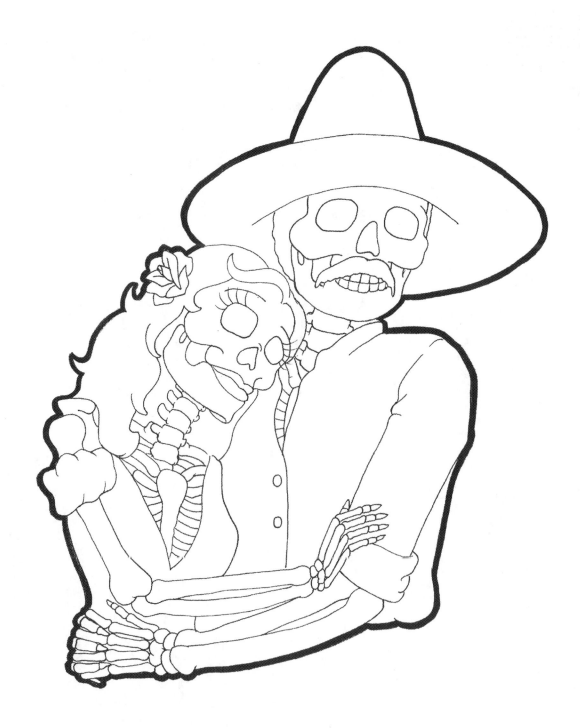

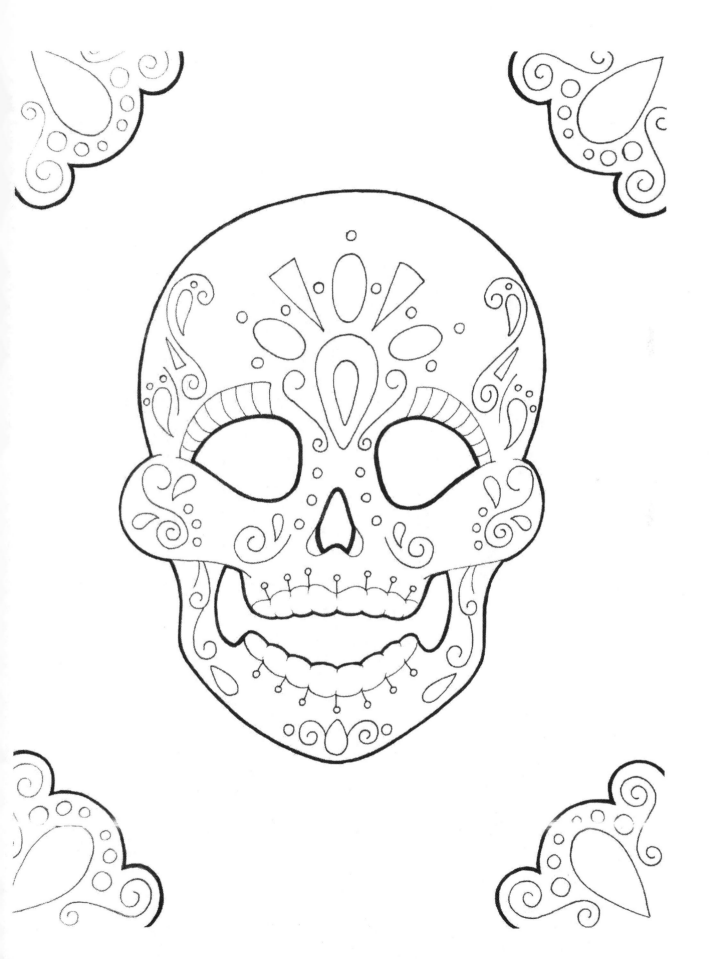

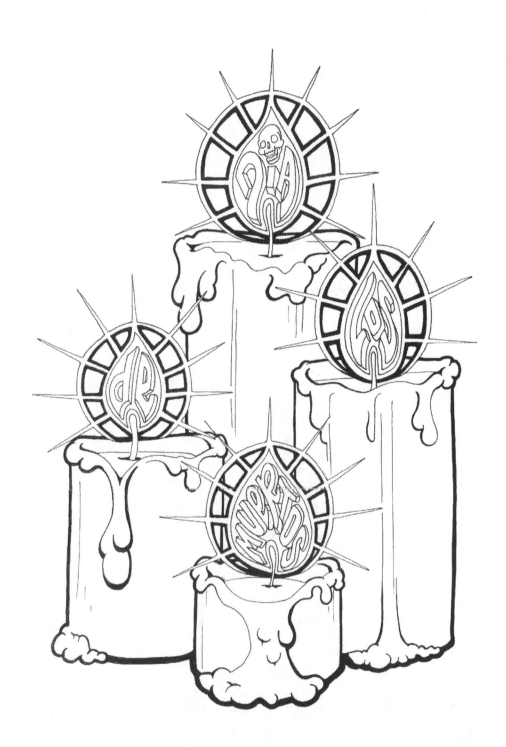

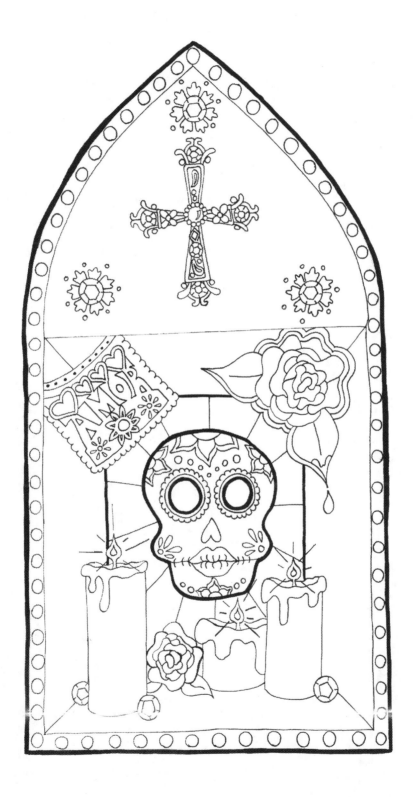

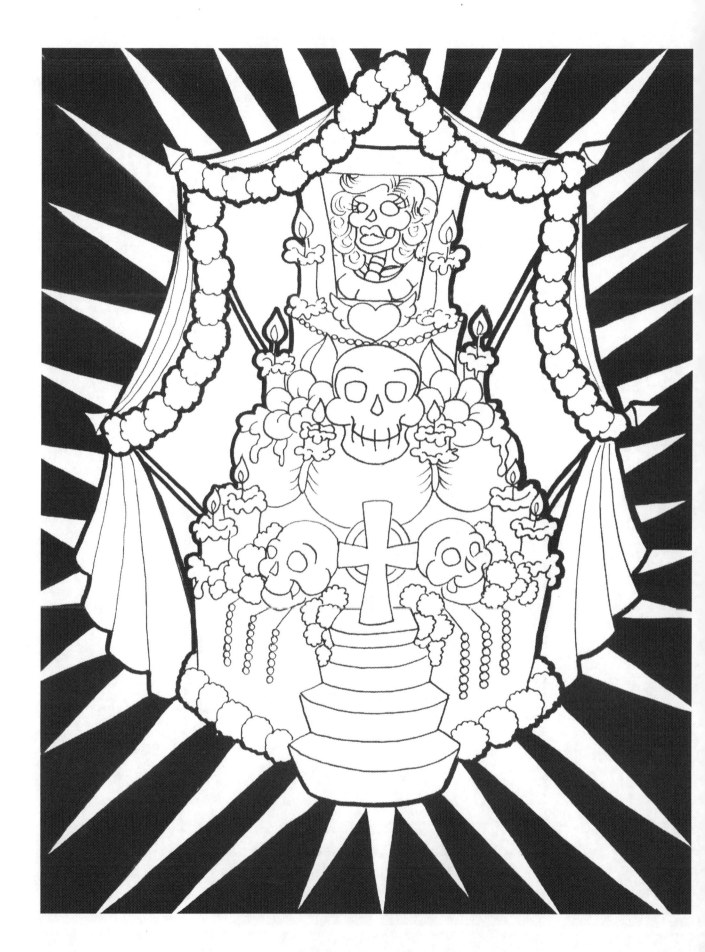

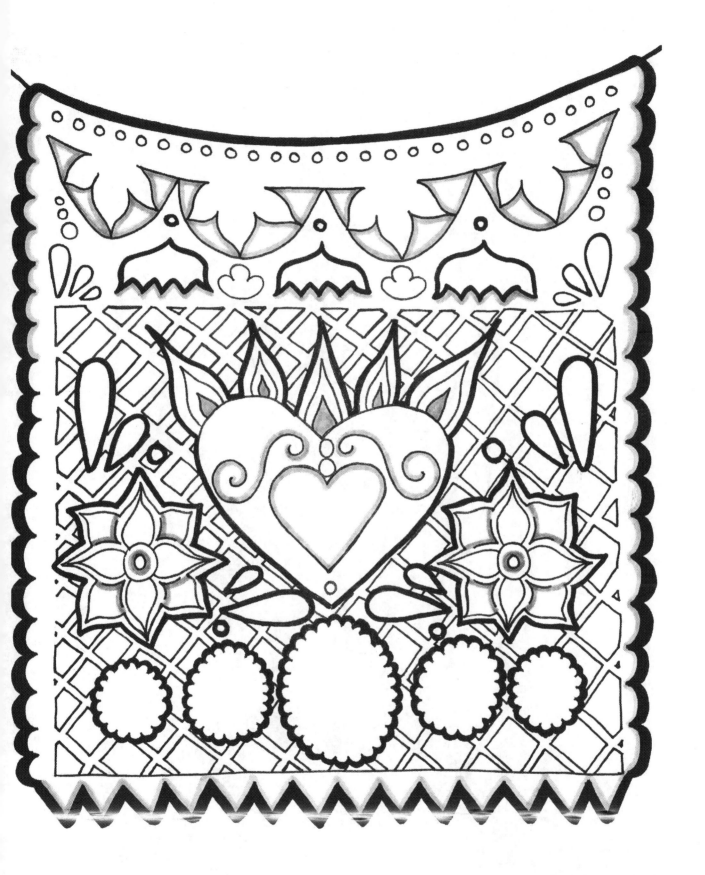

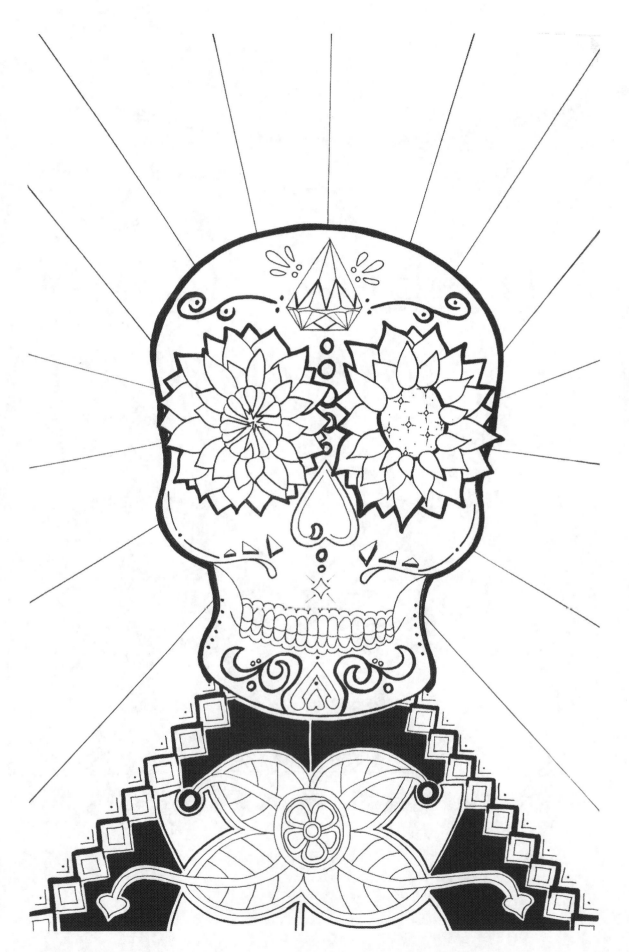

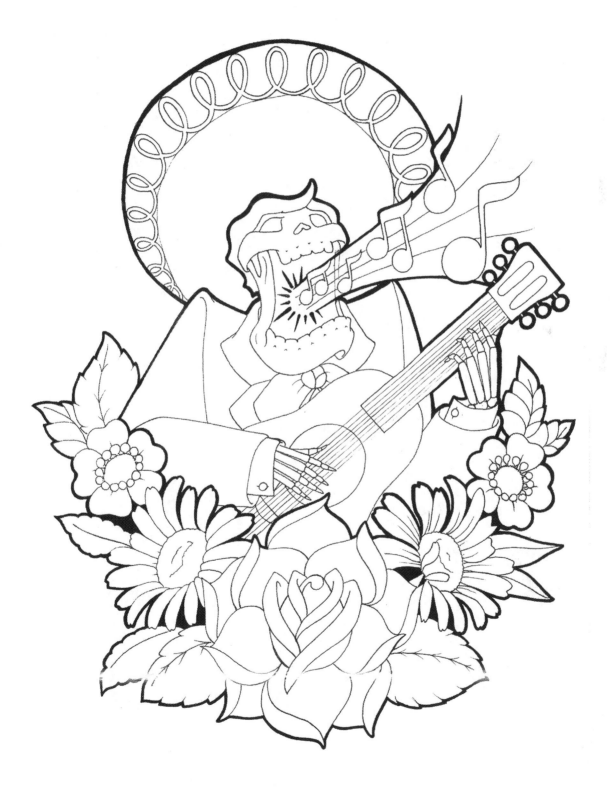

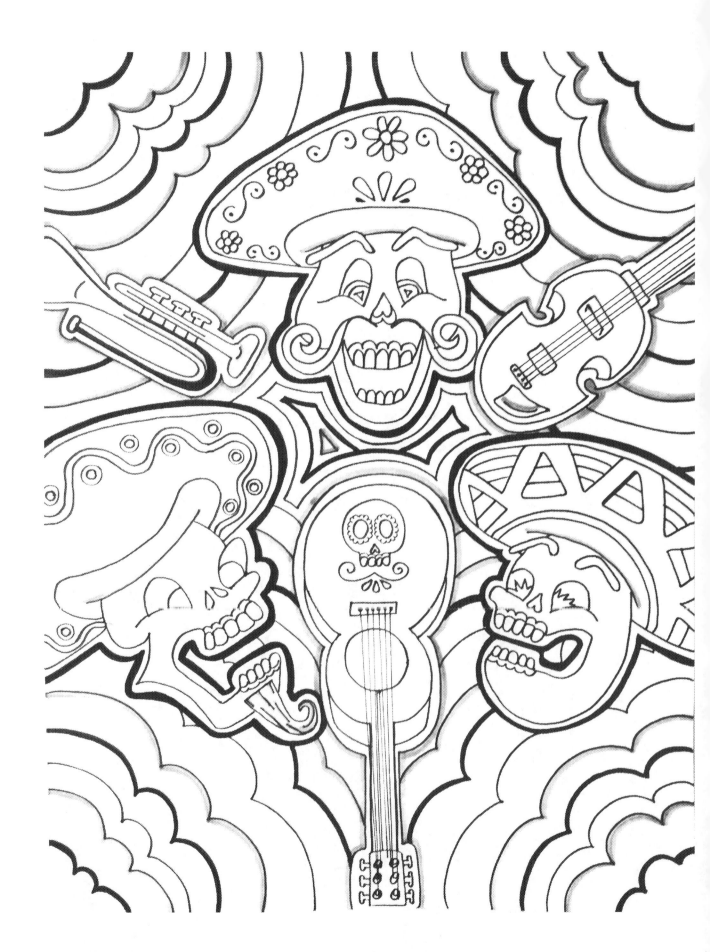

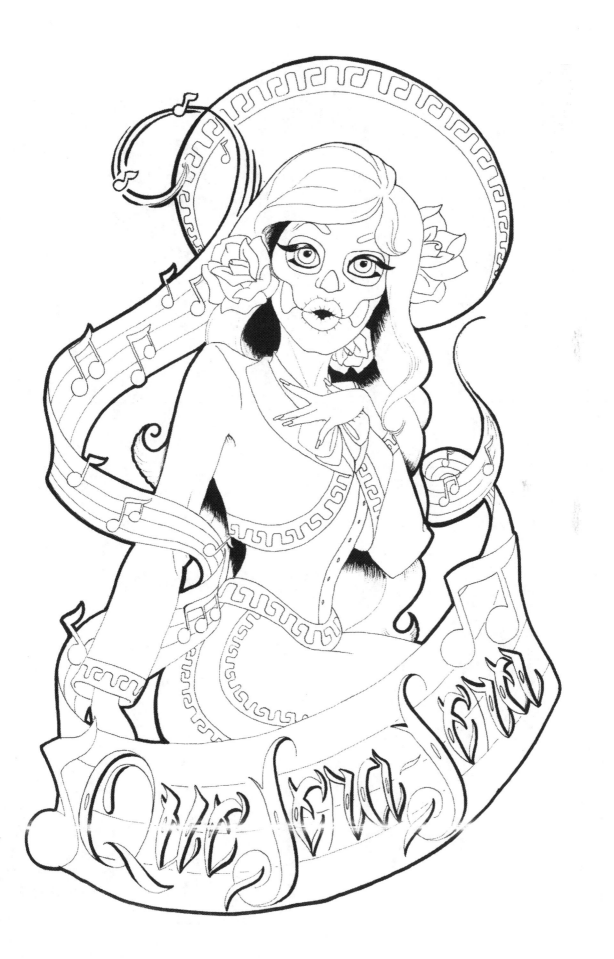

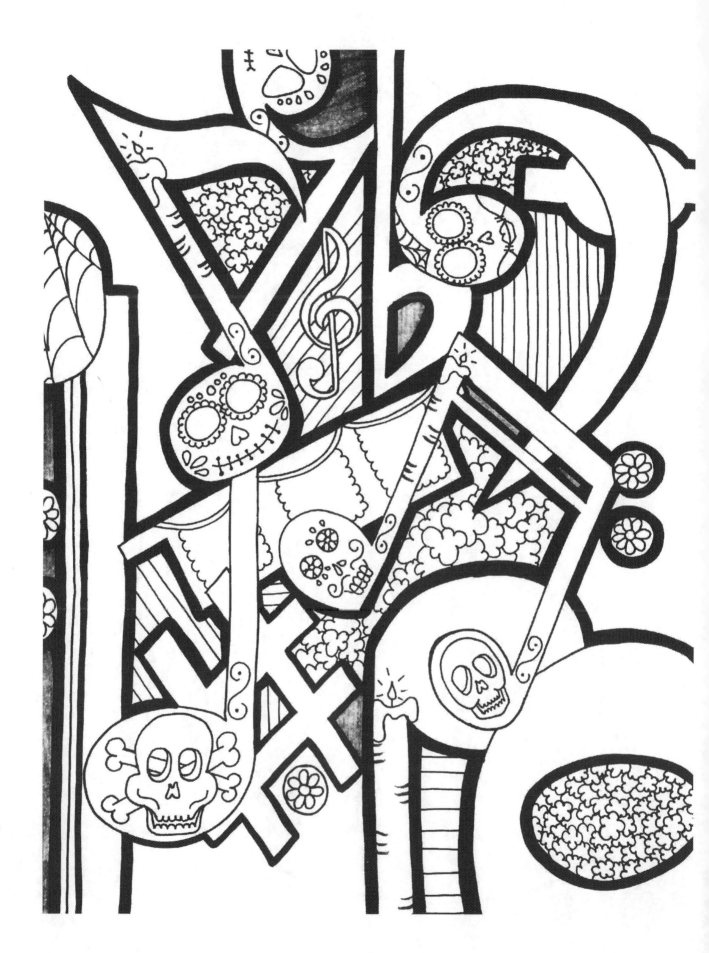

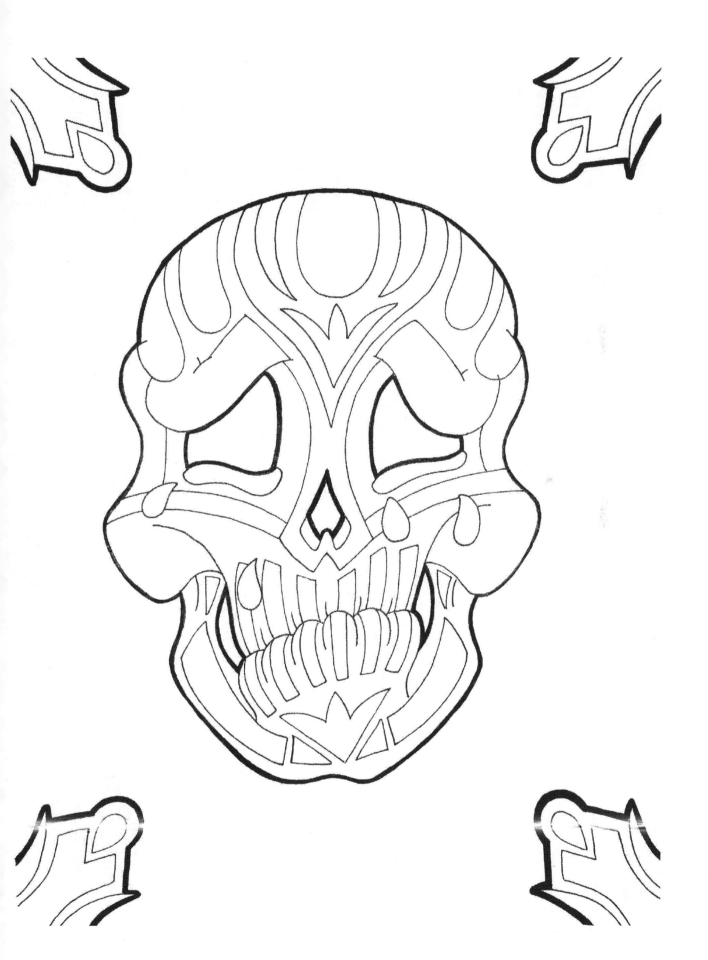

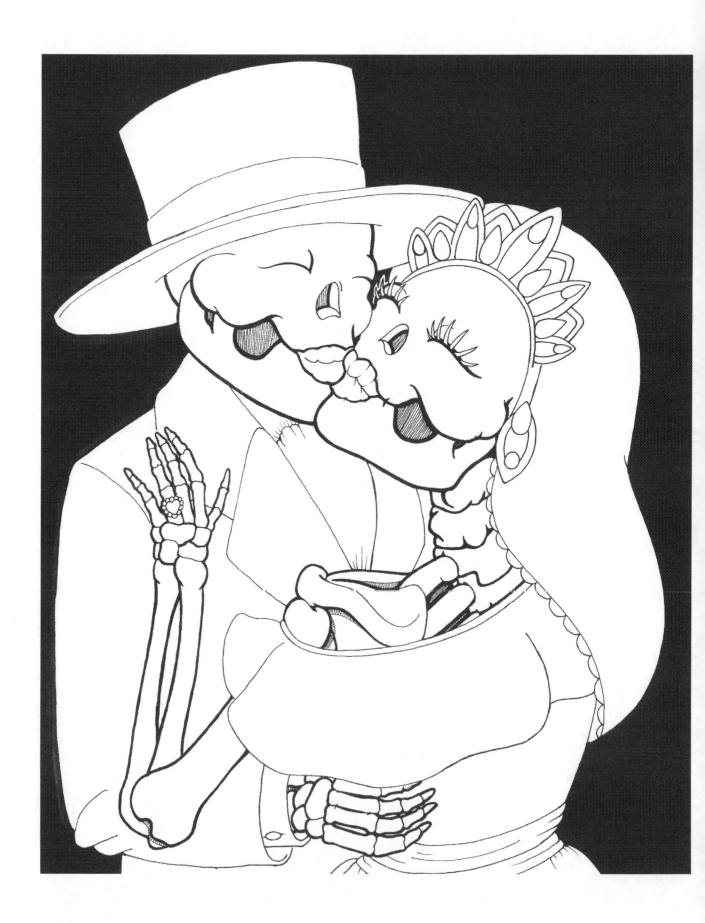

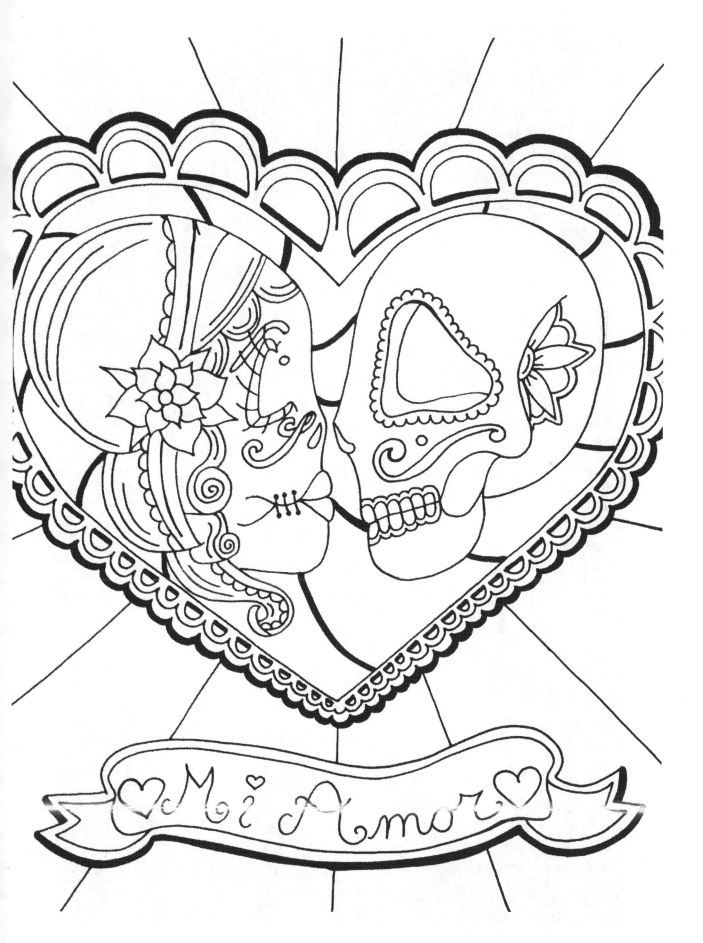

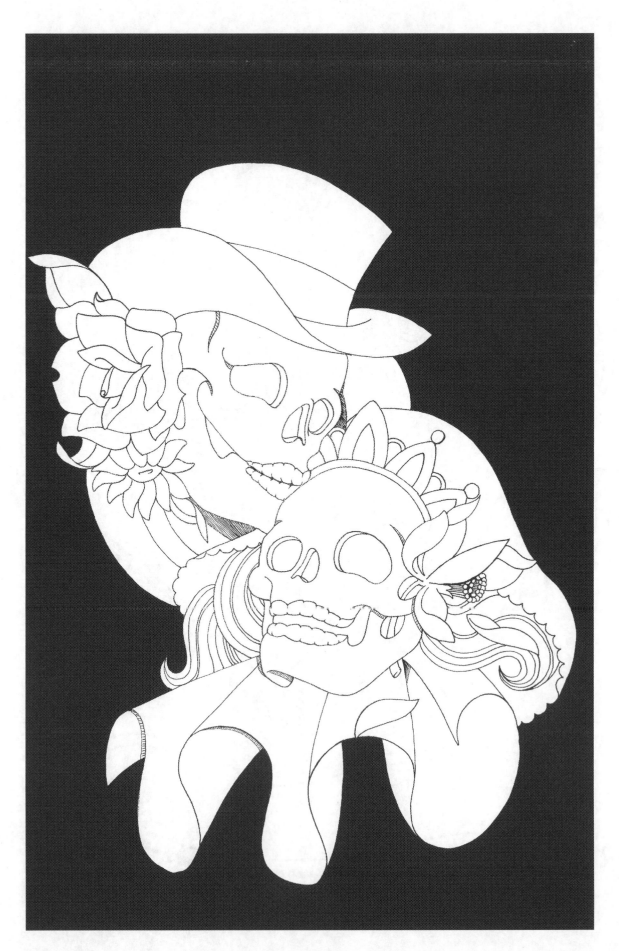

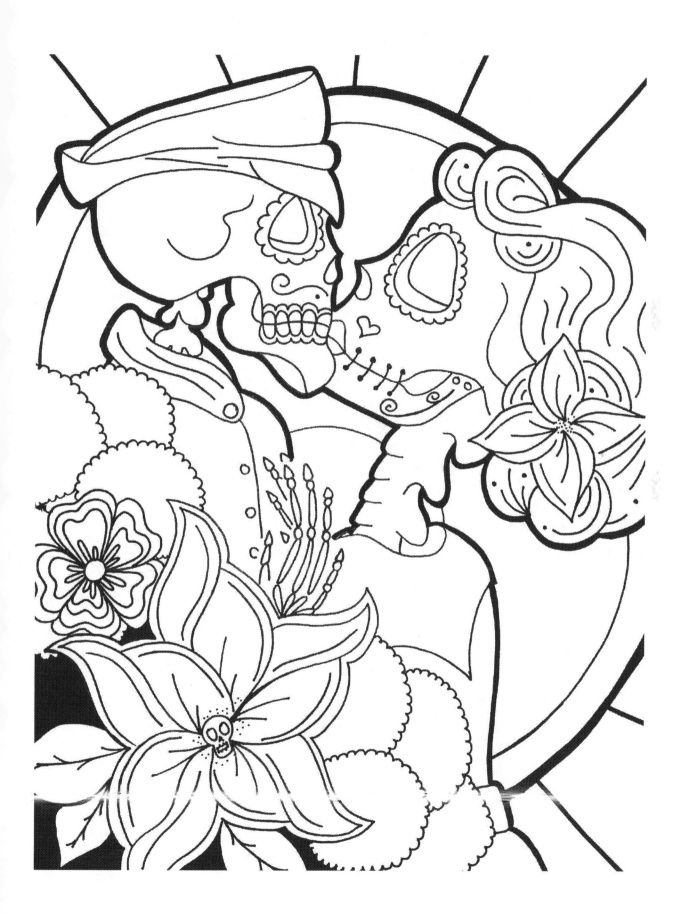

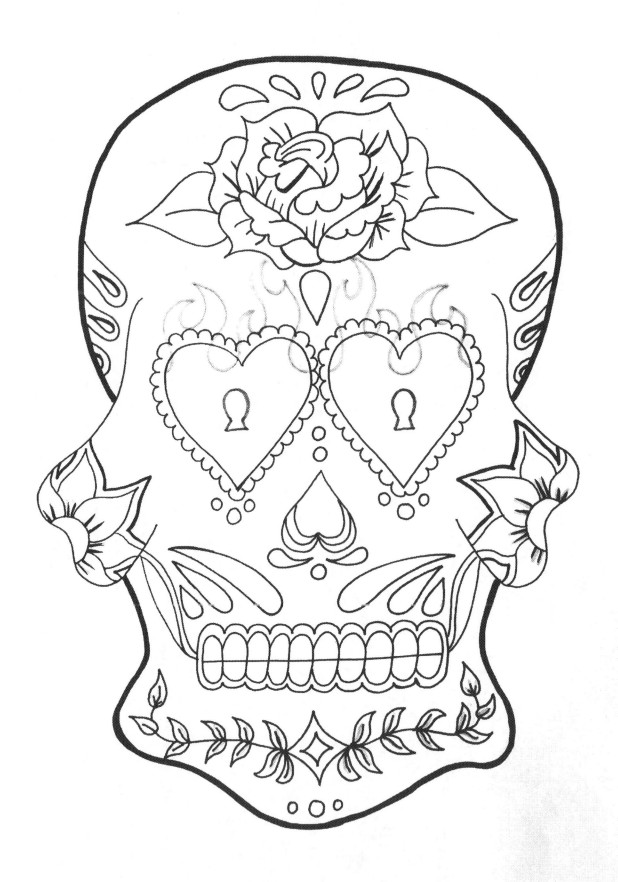

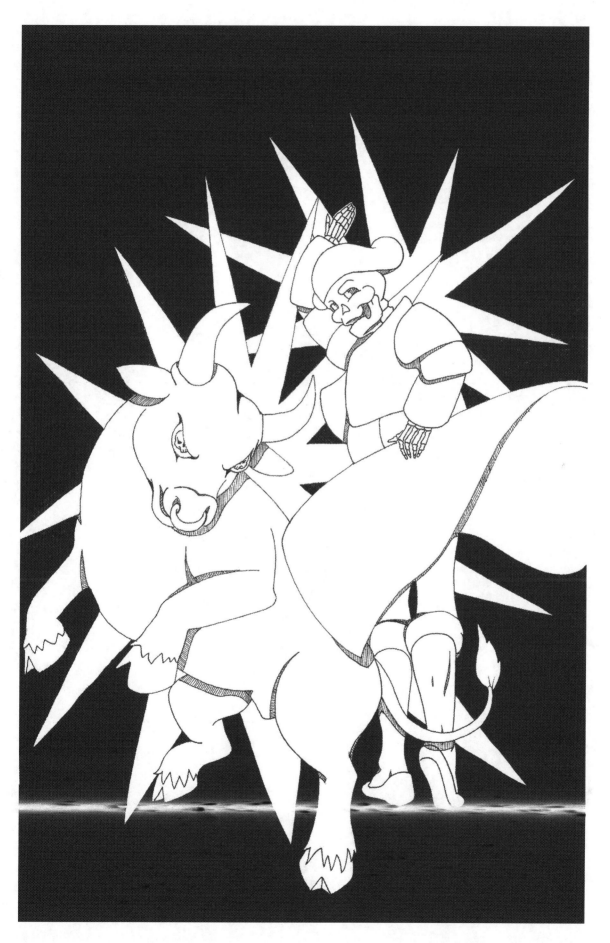

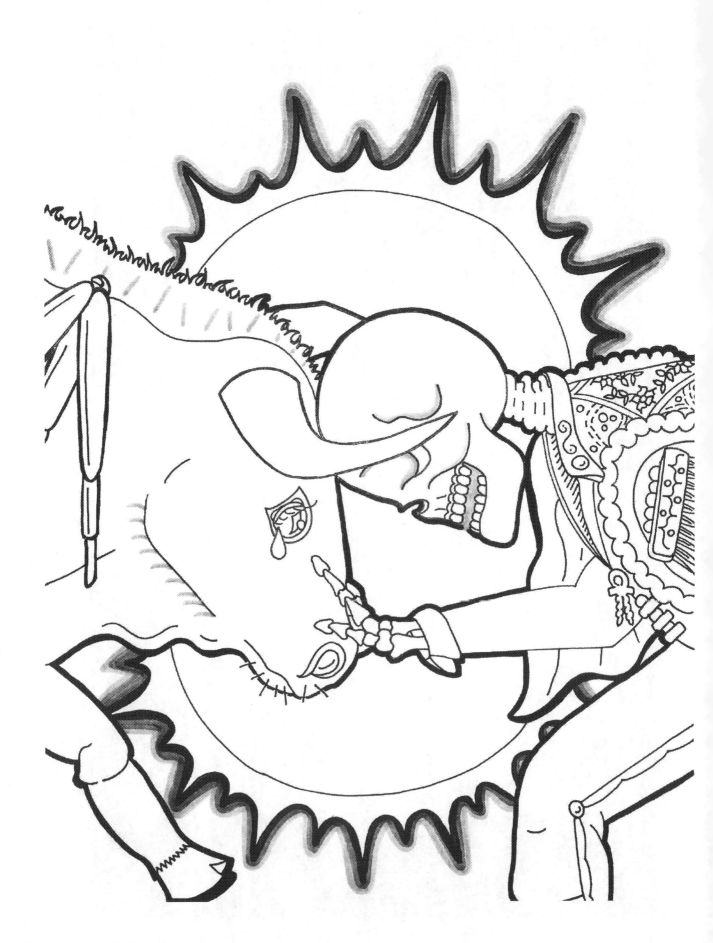

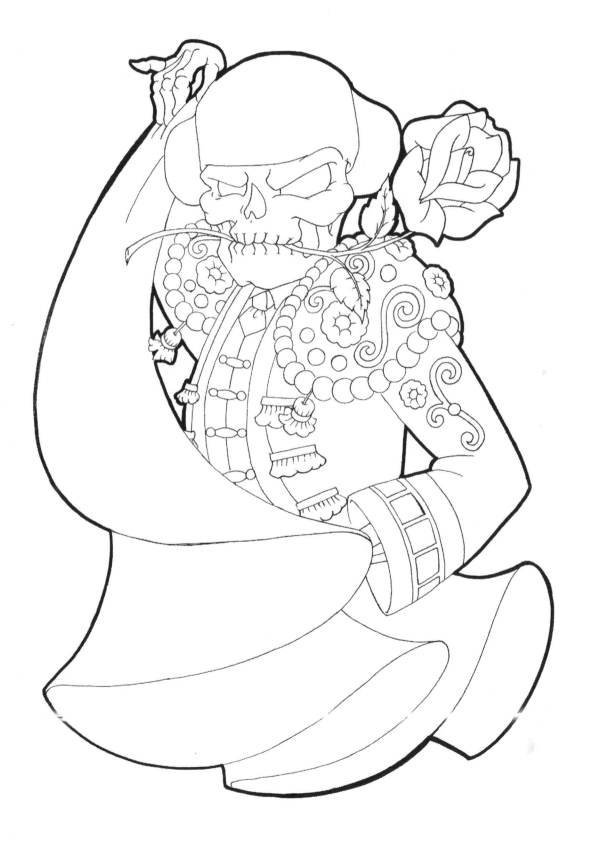

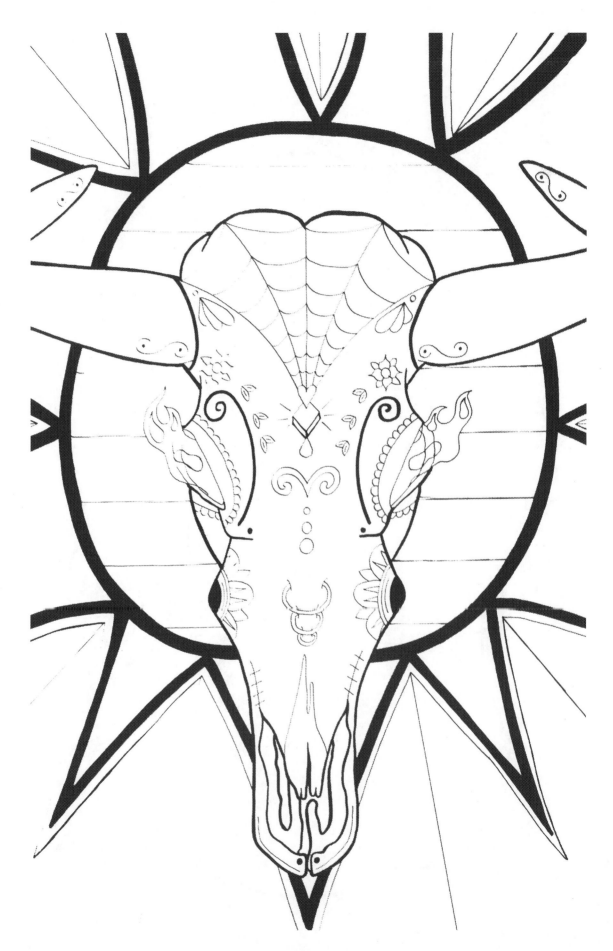

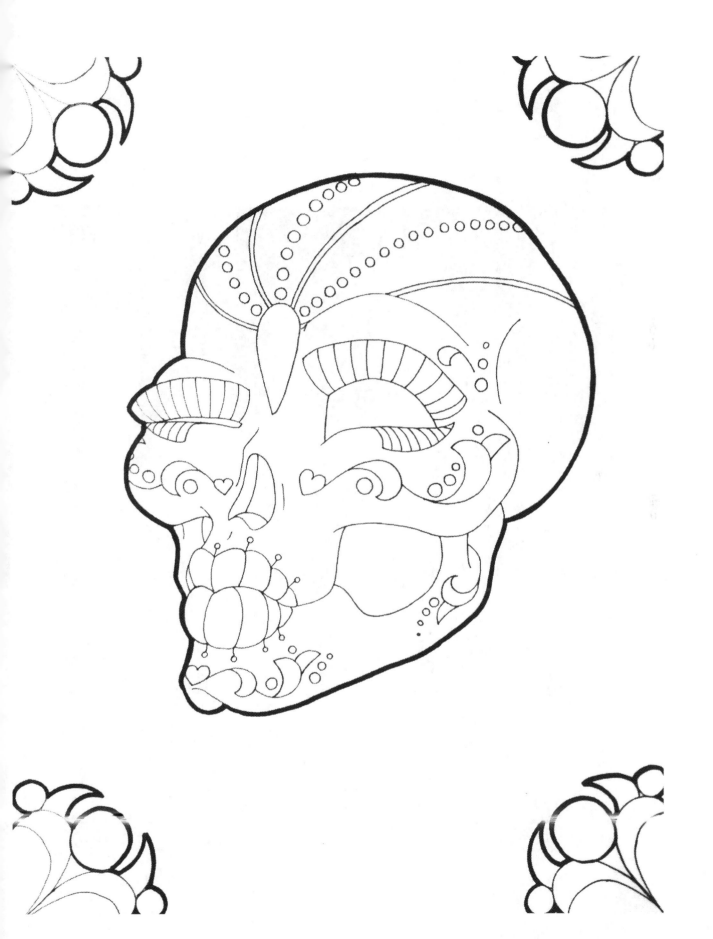

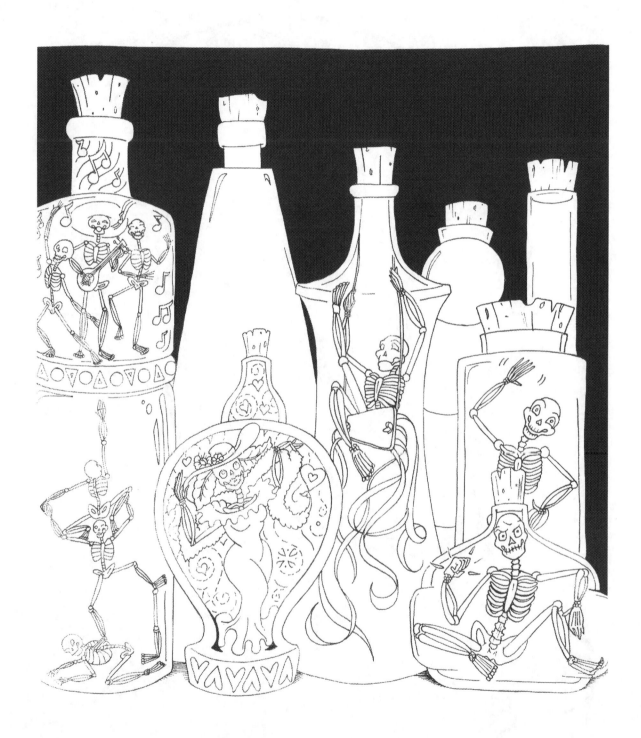

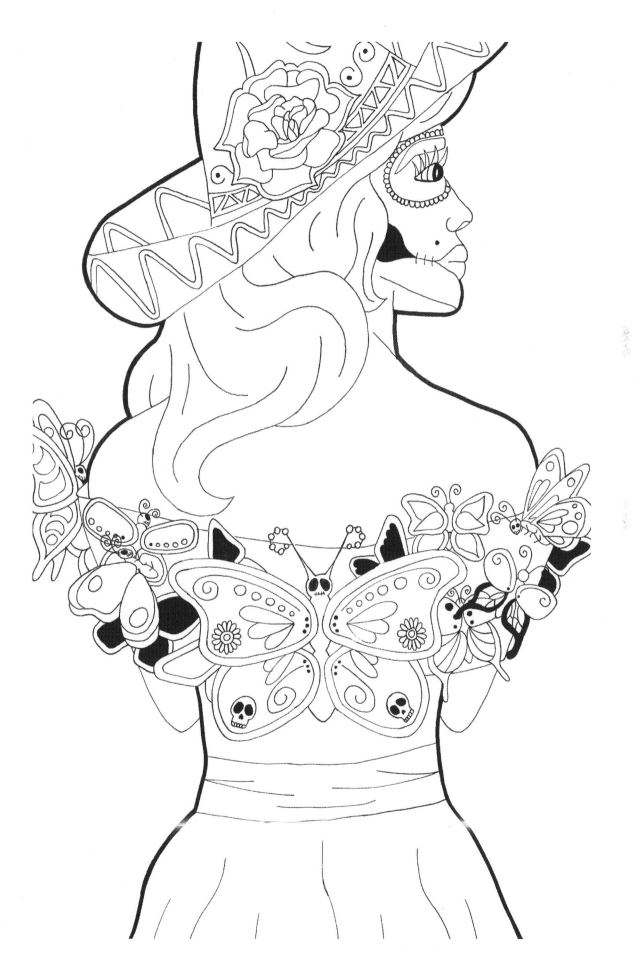

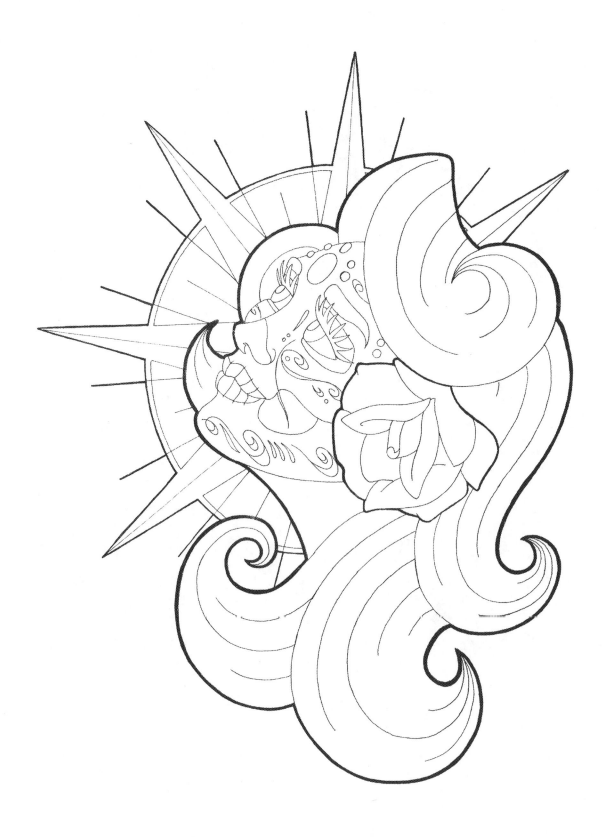

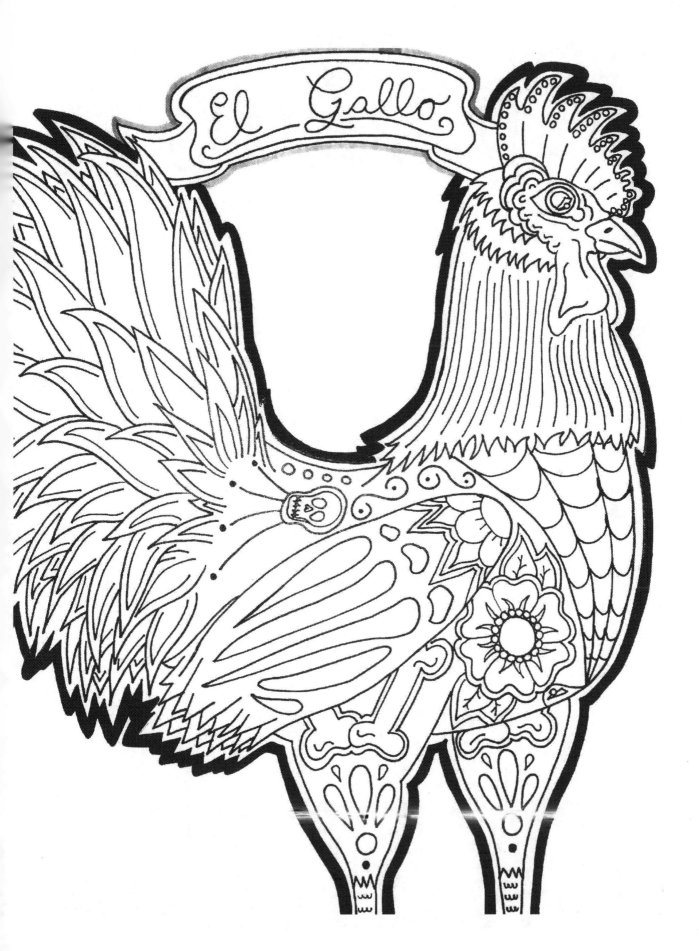

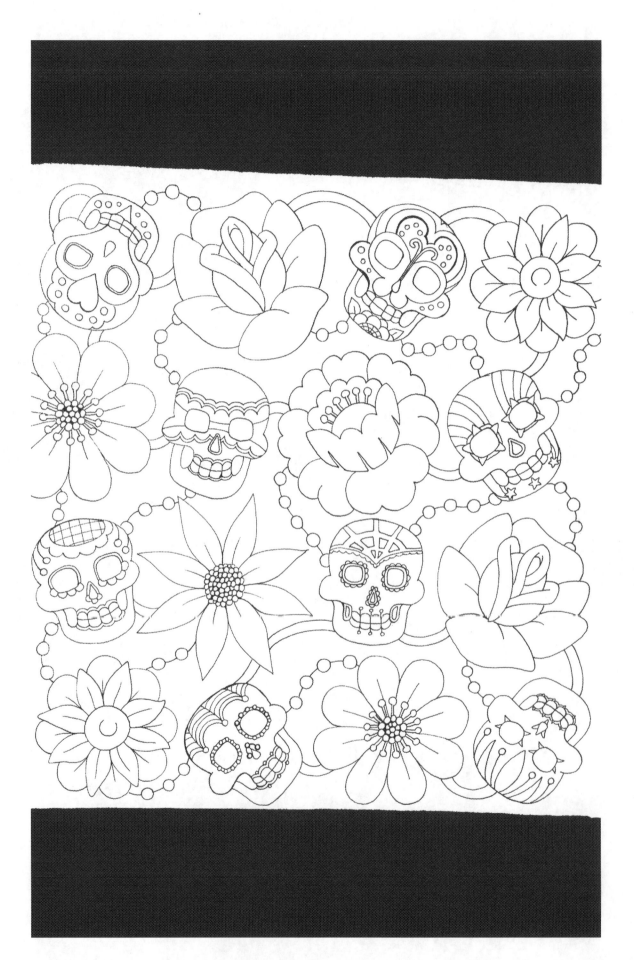

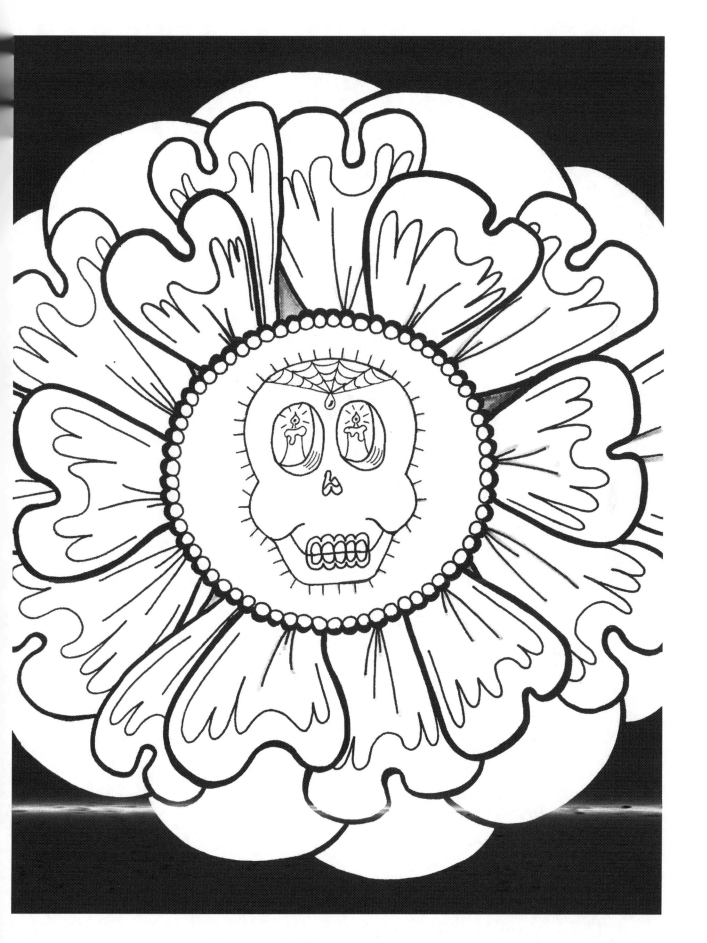

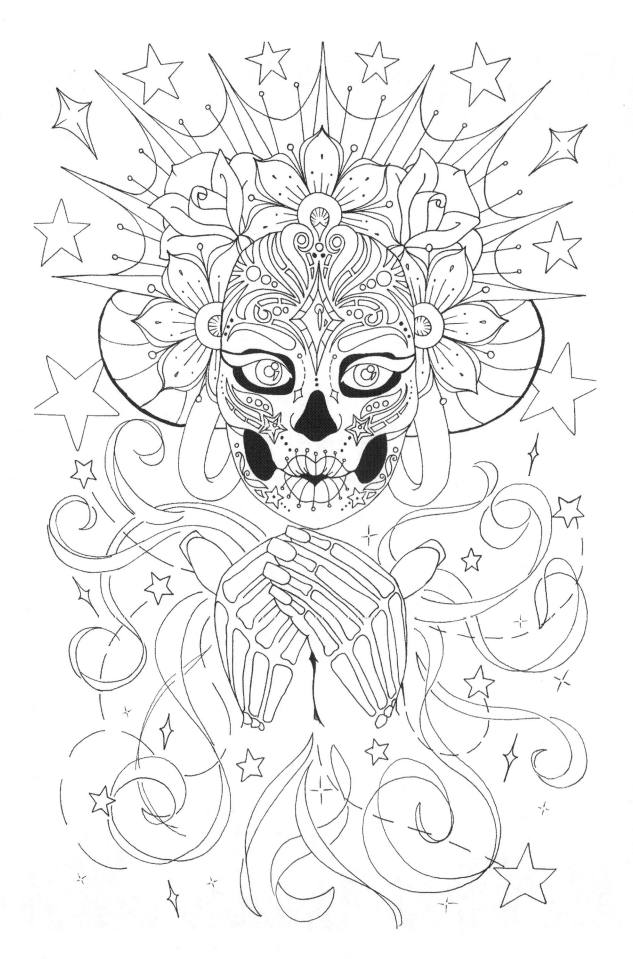

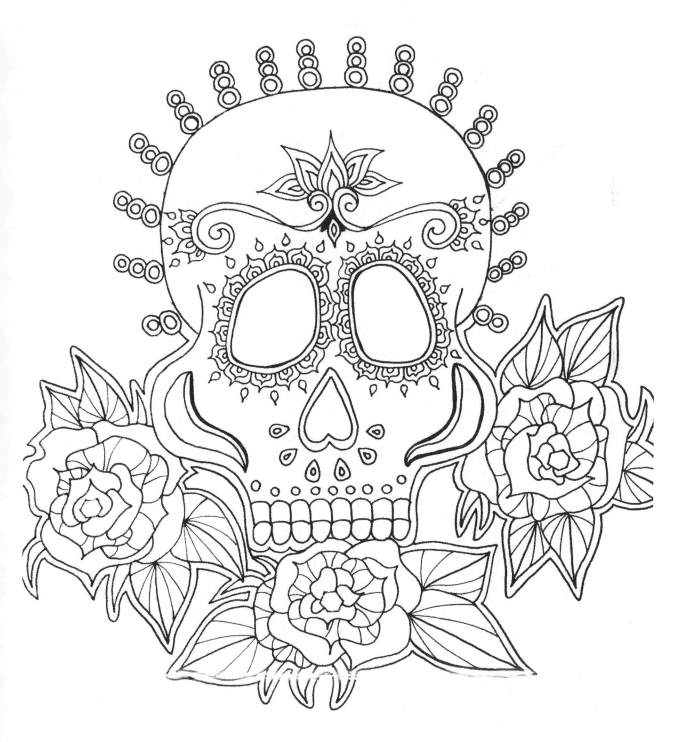

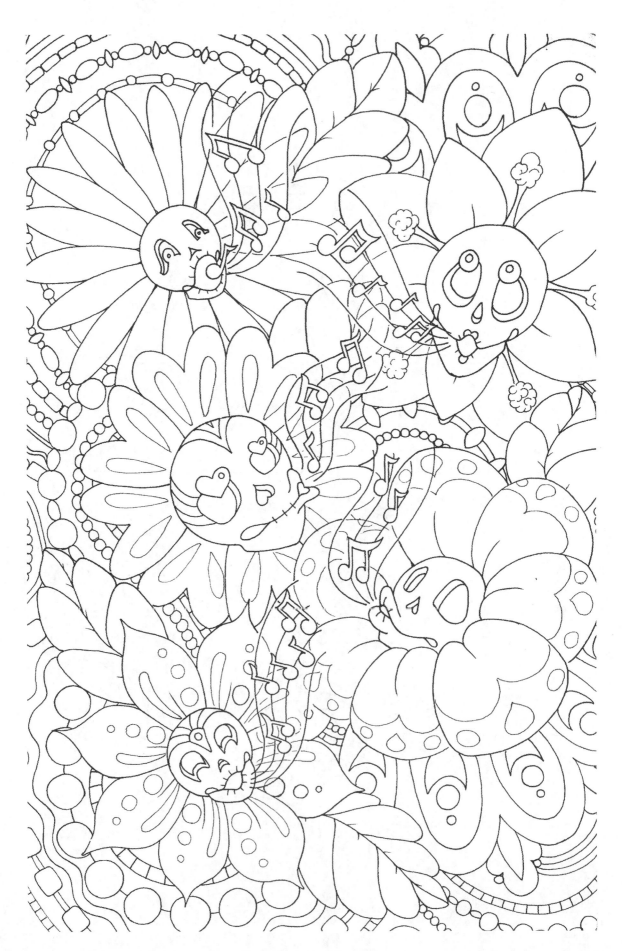

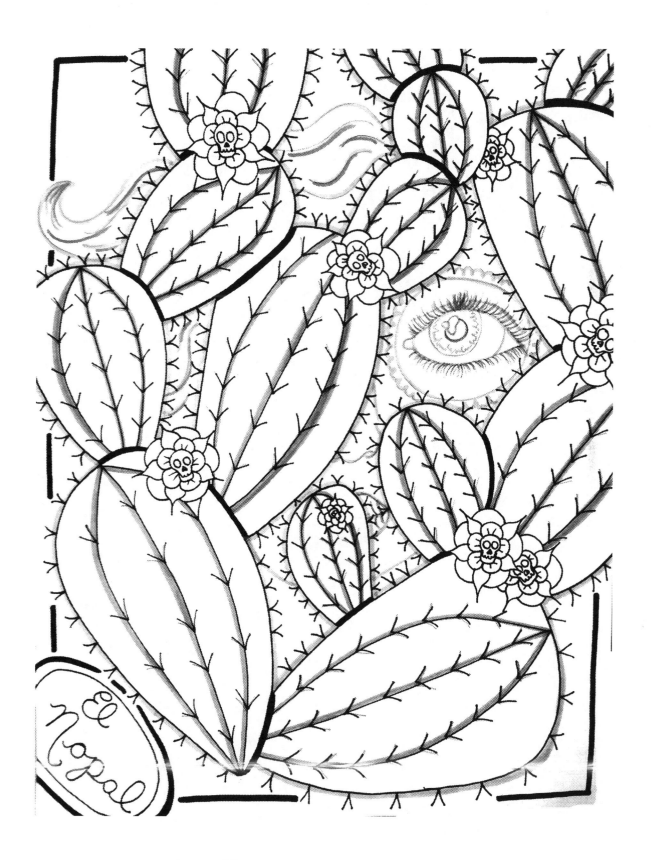

El Nopal

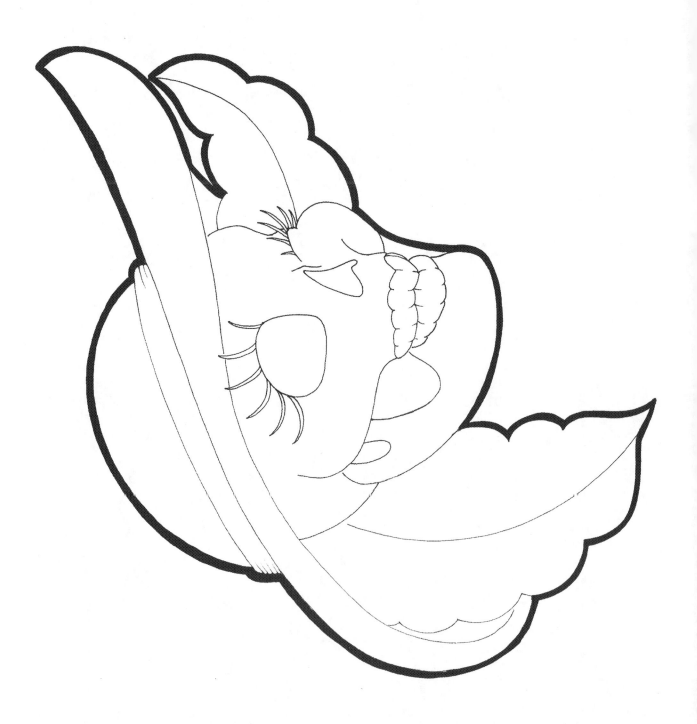

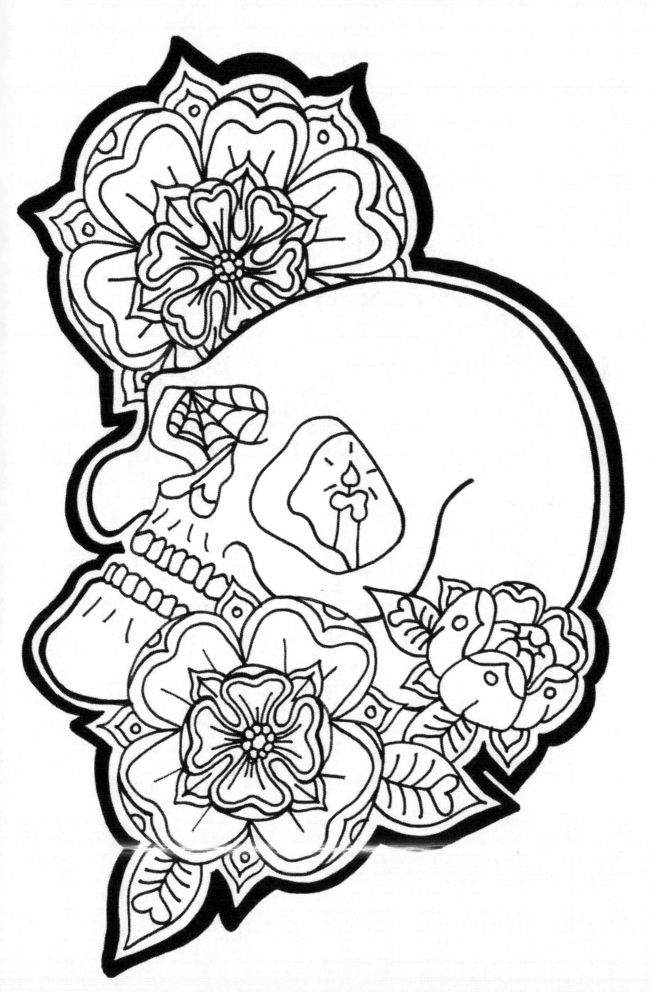

49

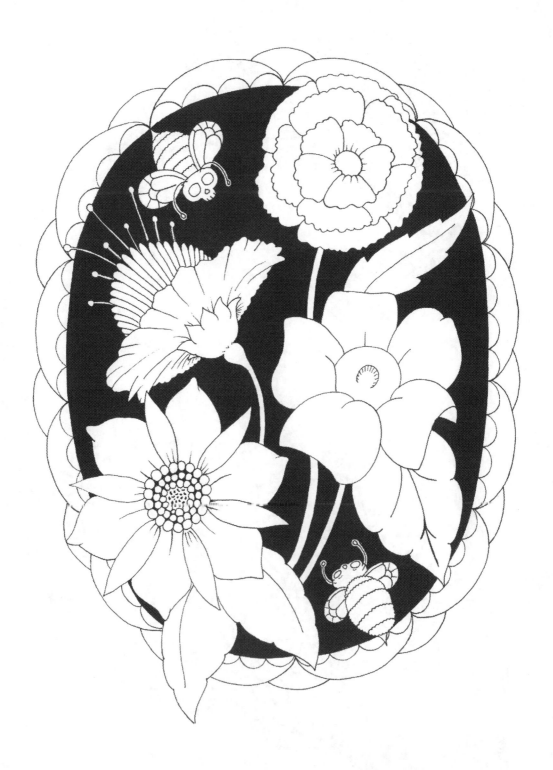

50

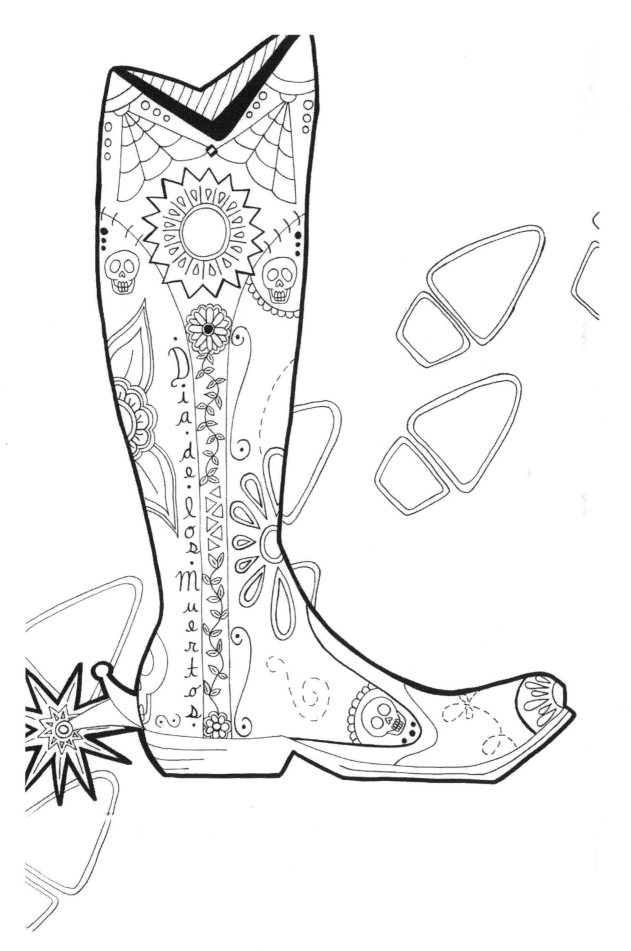

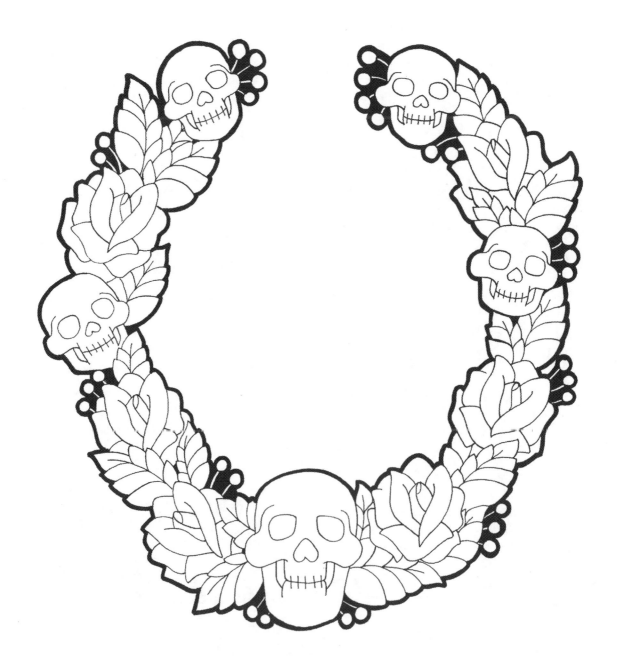

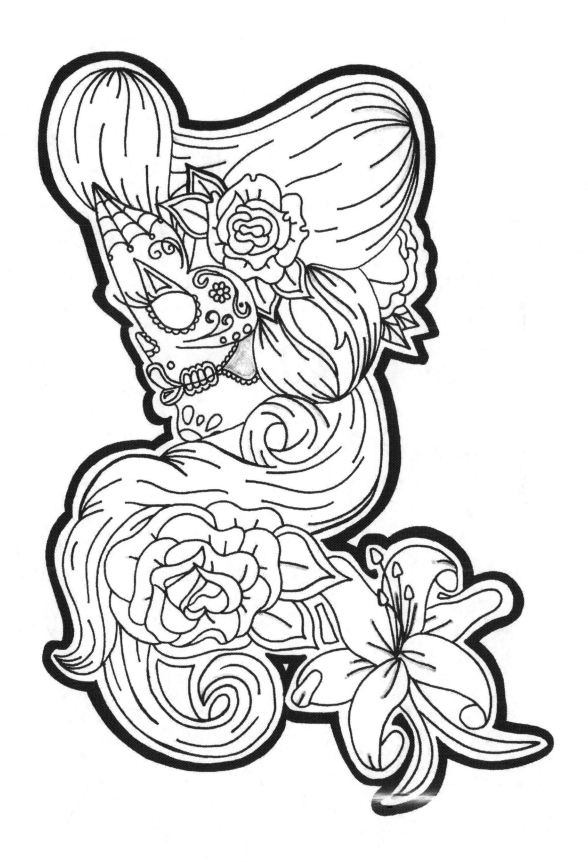

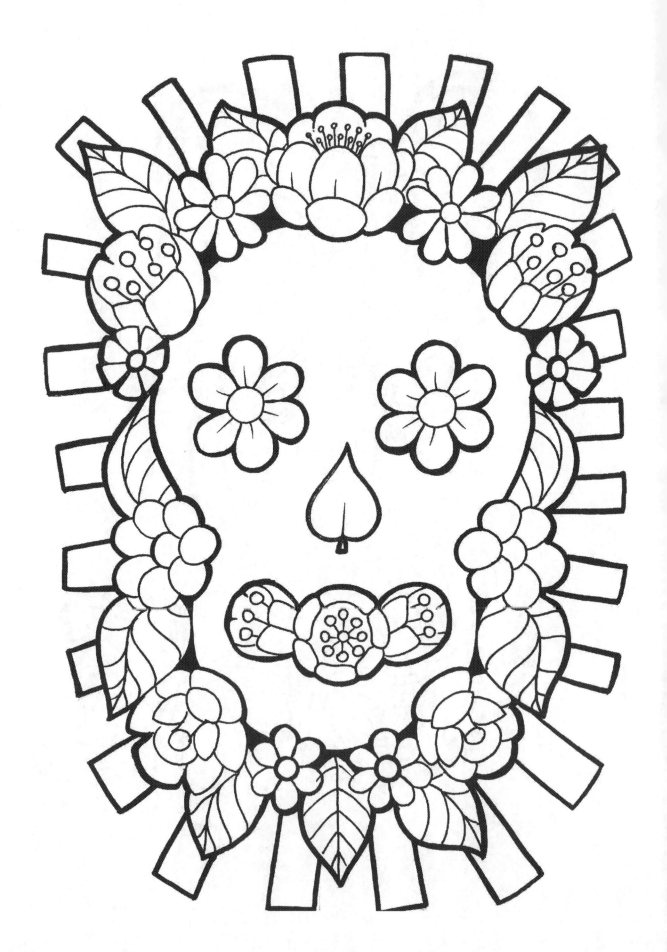

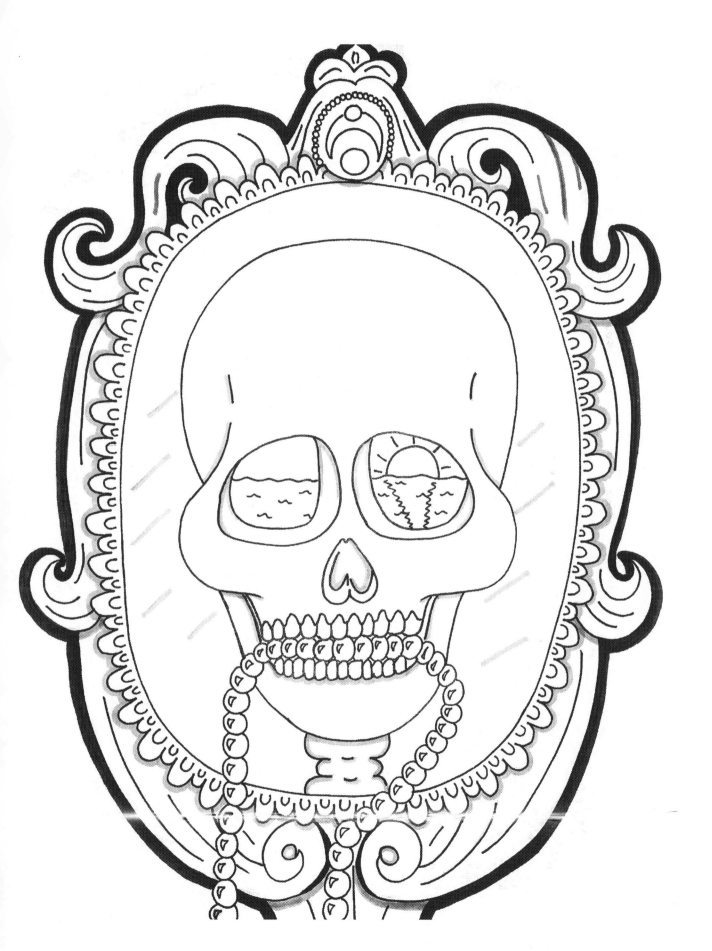

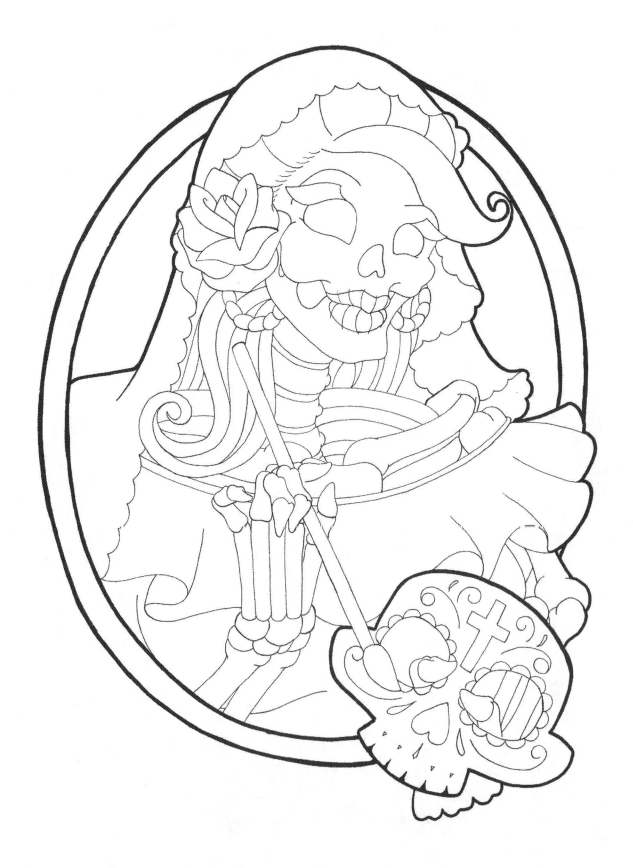

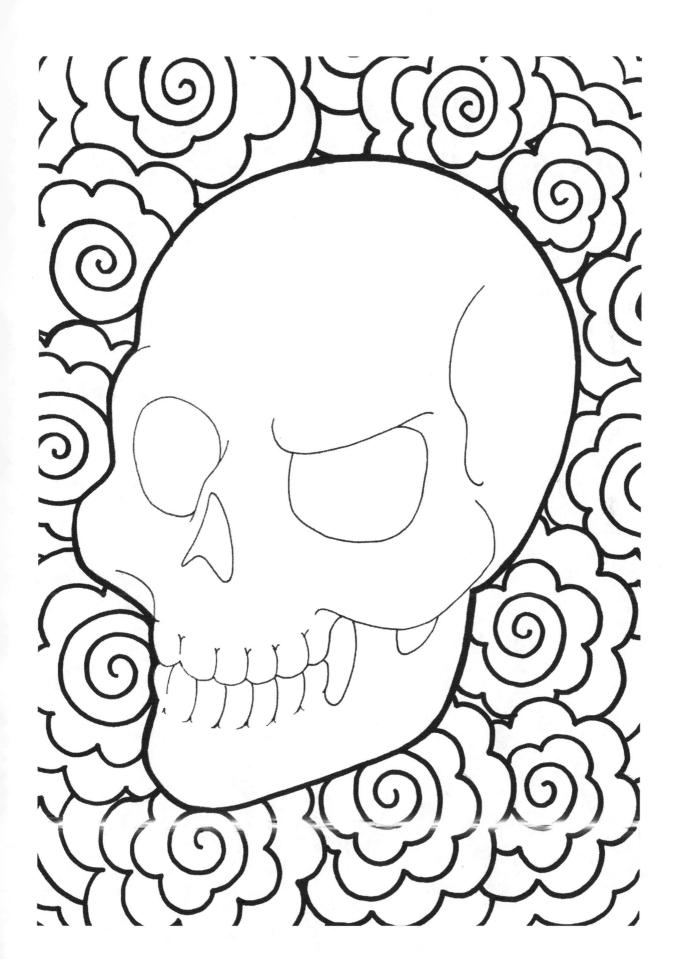

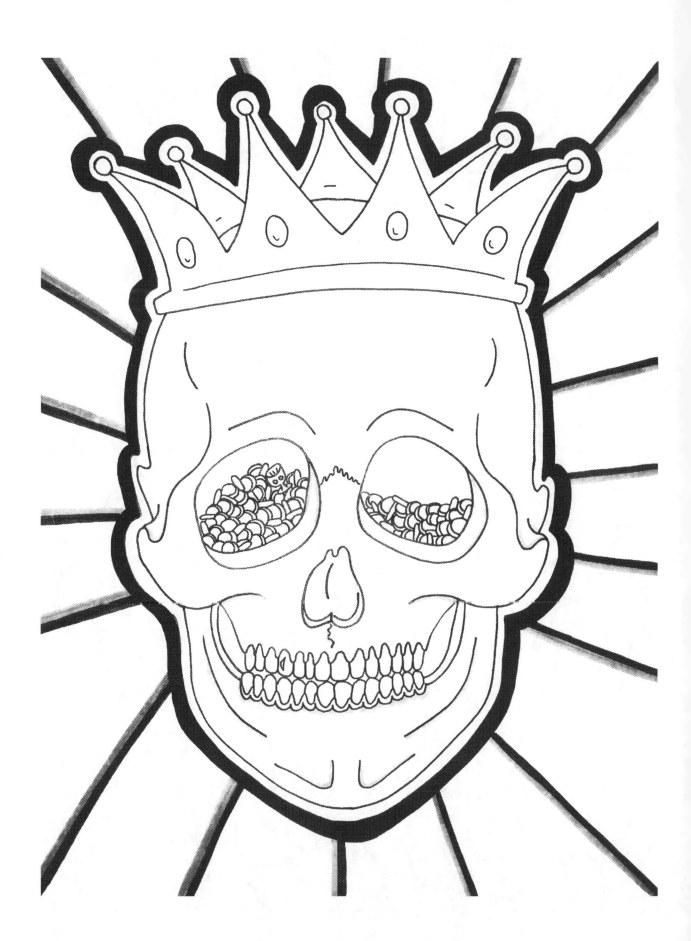

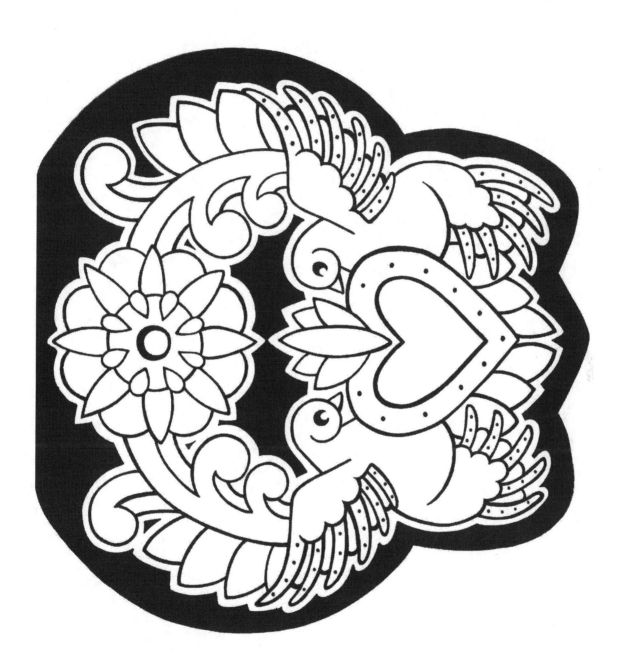

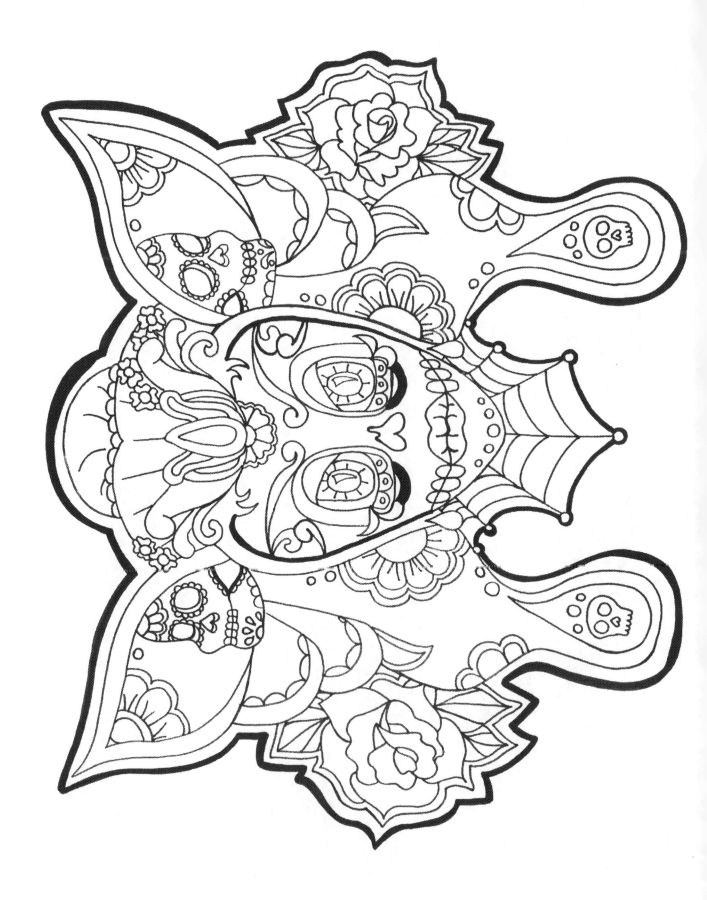

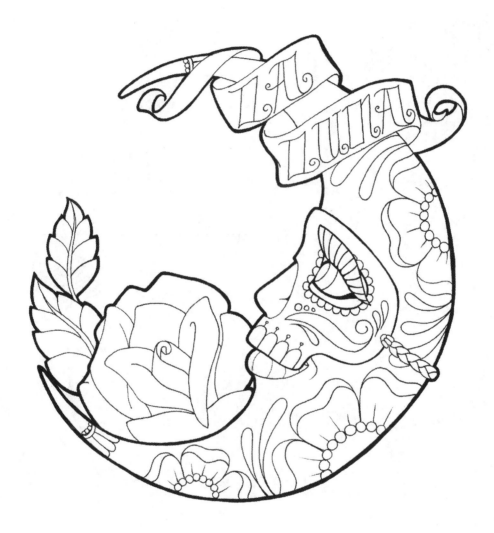

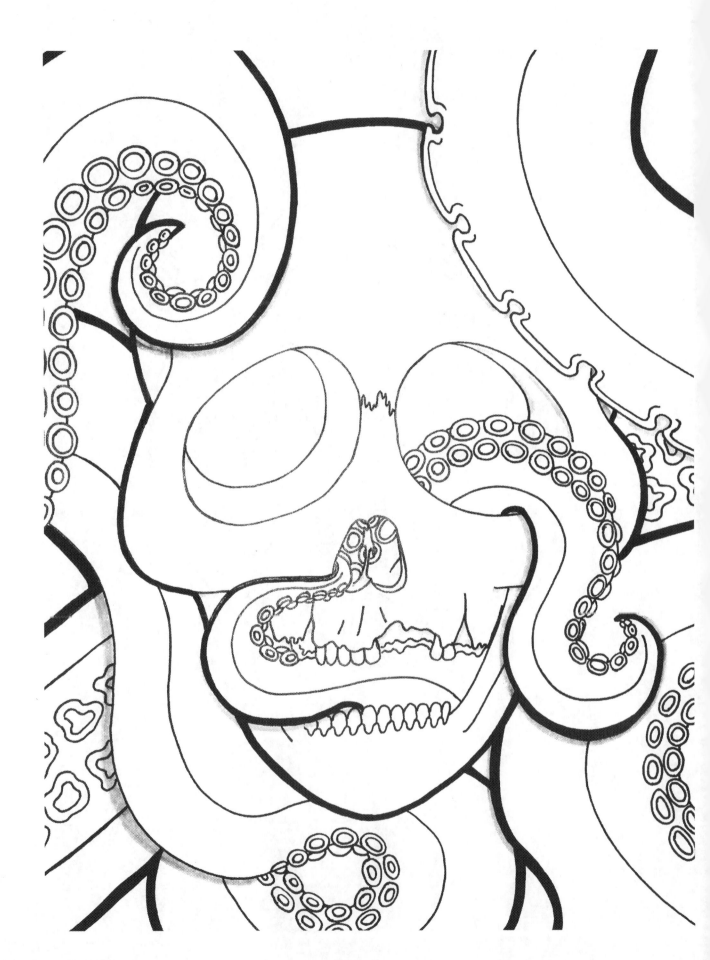

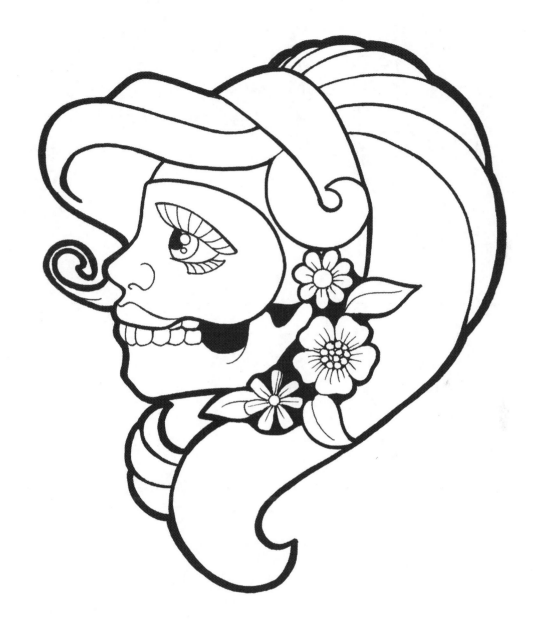

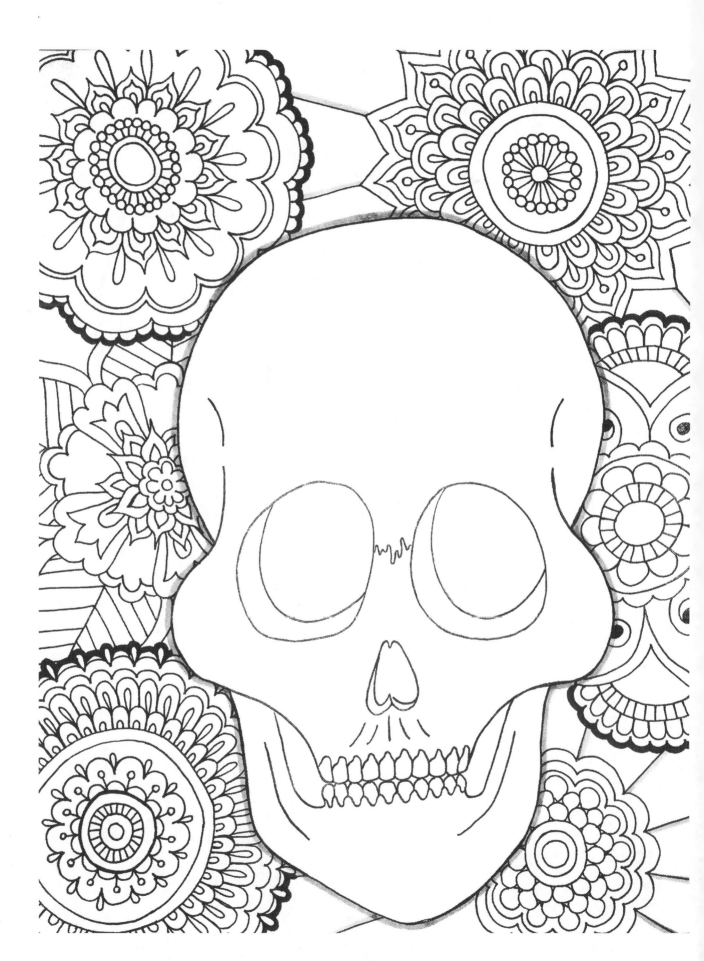

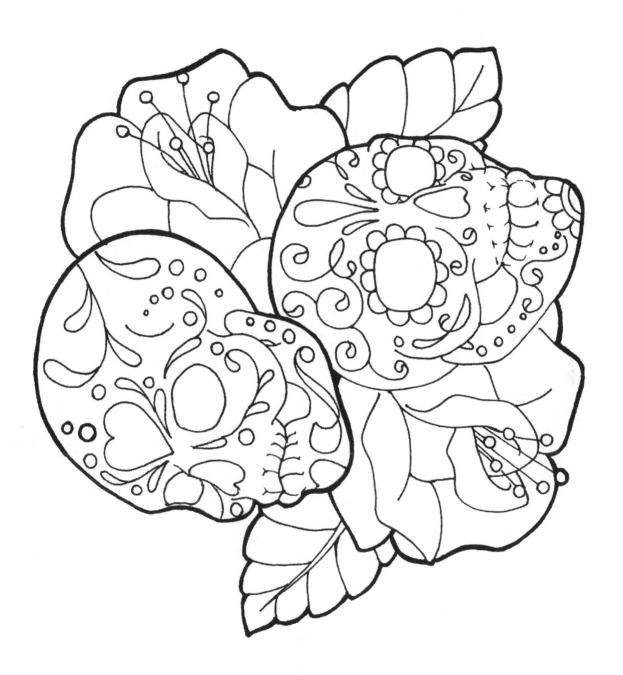

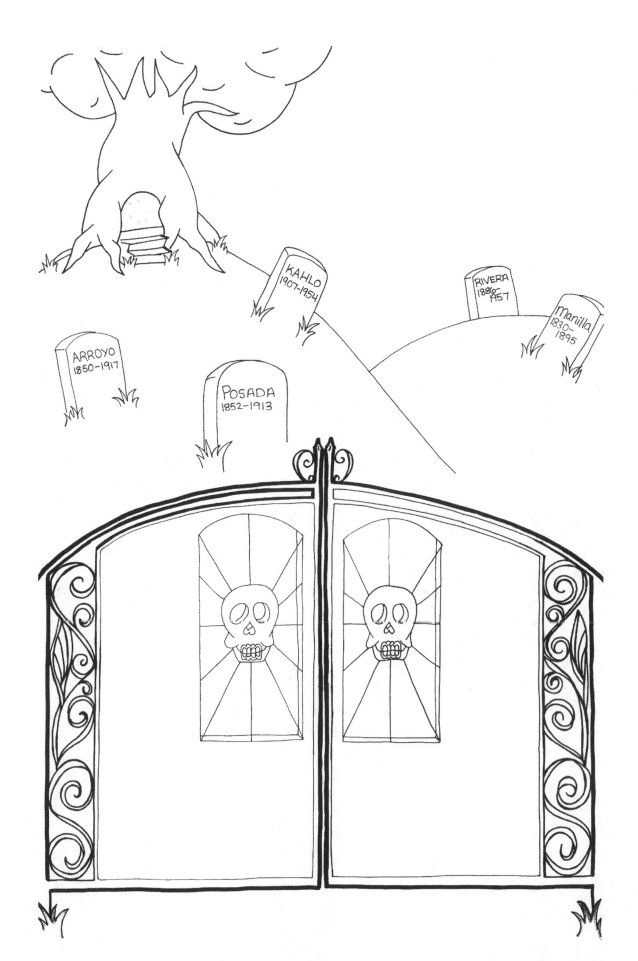

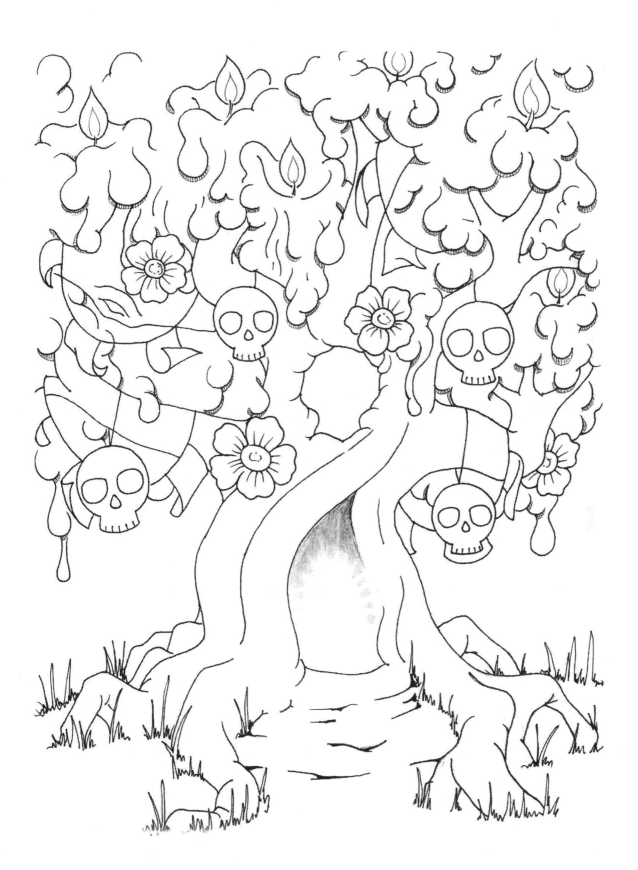

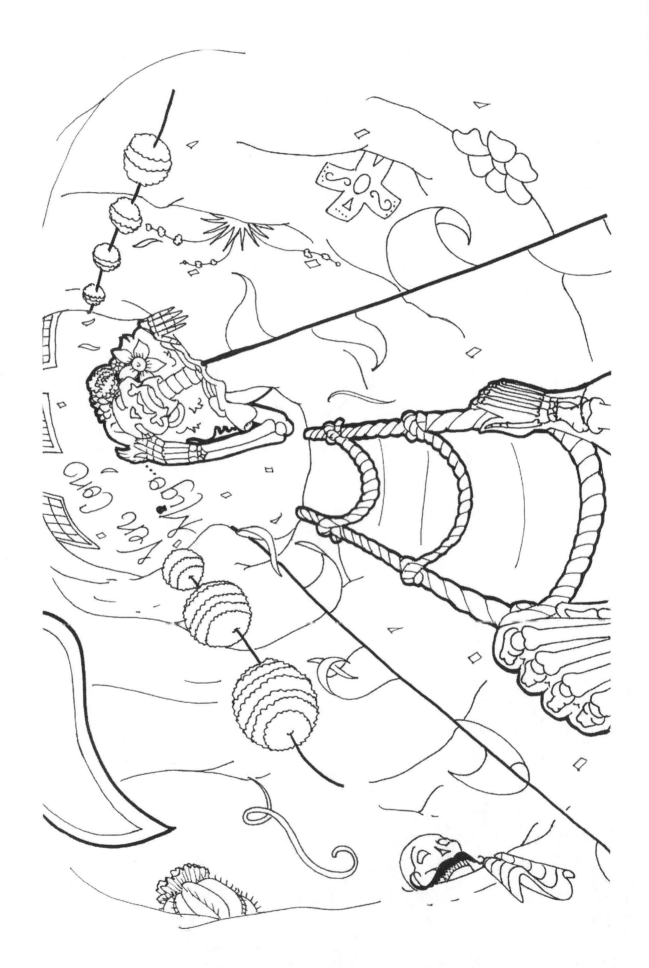

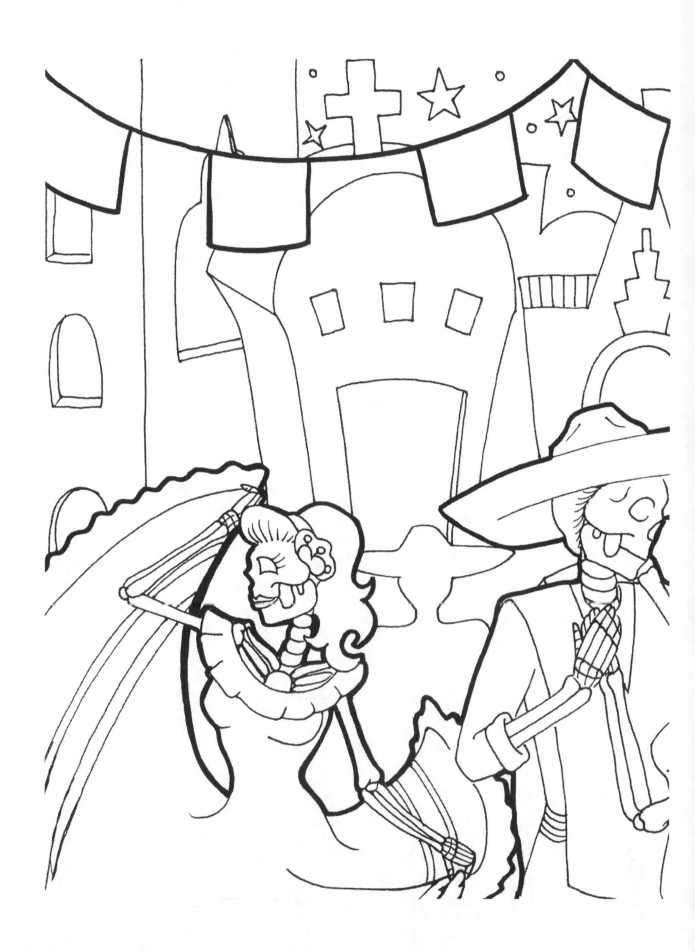

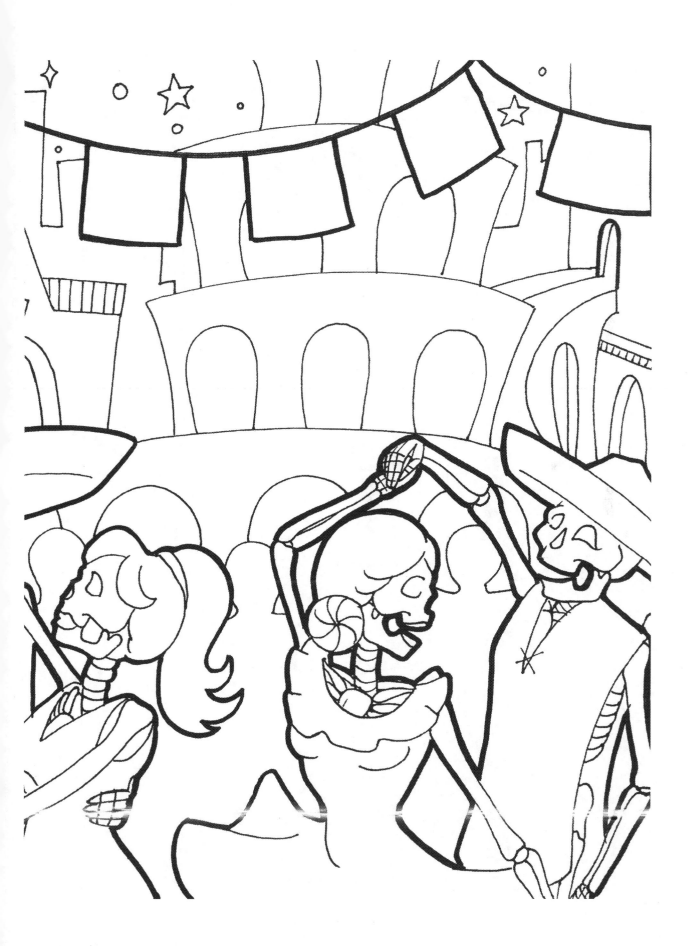

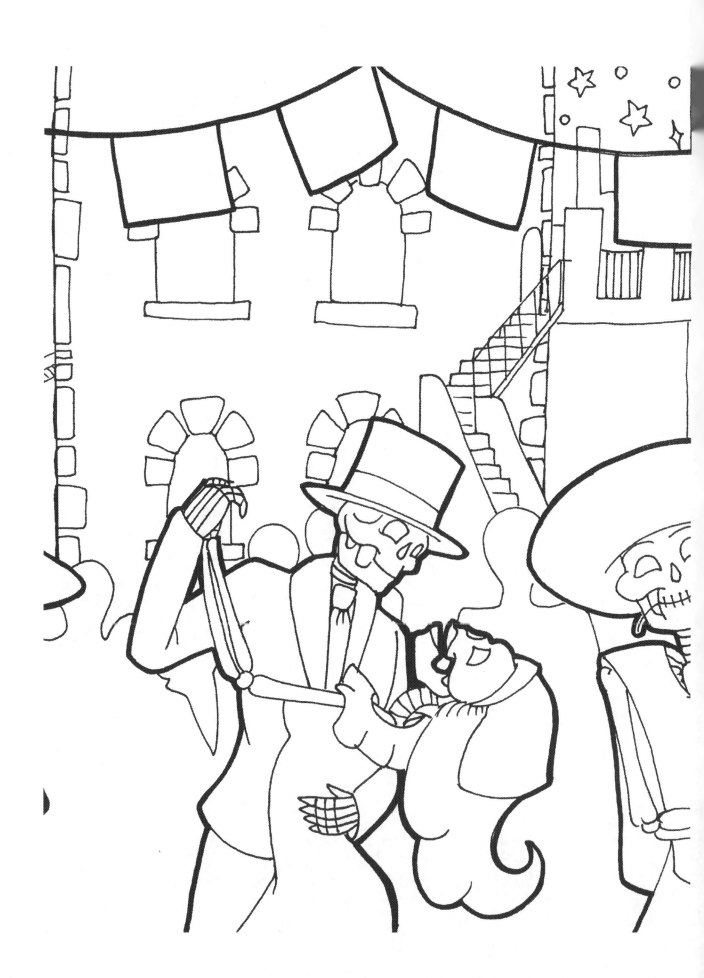

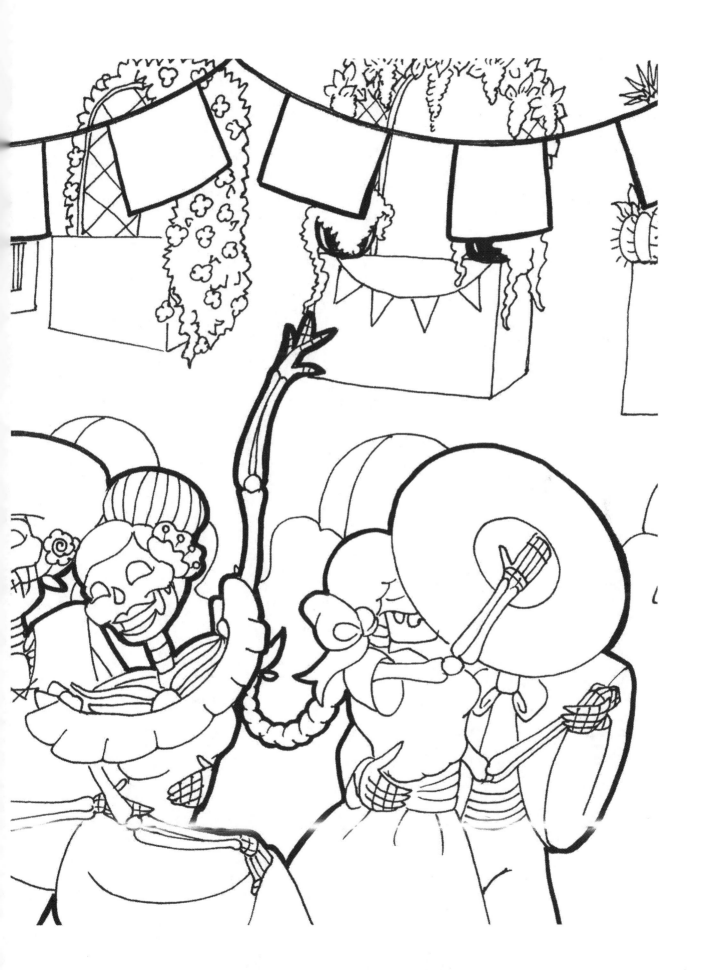

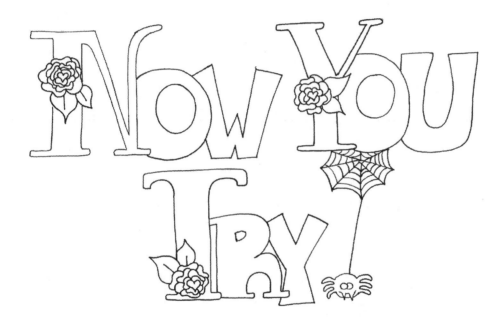

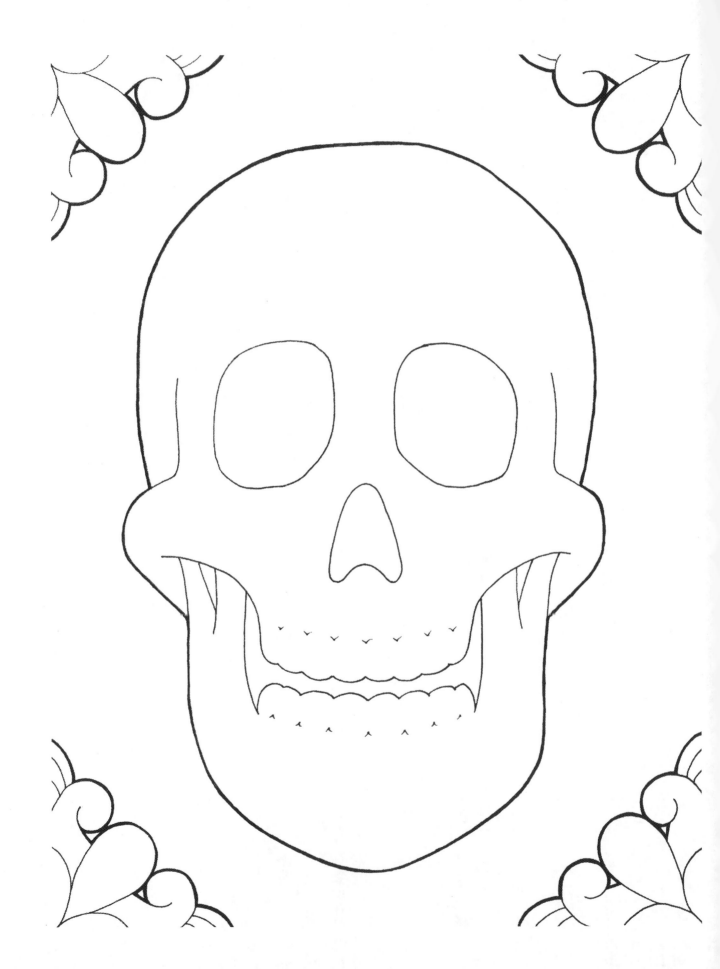

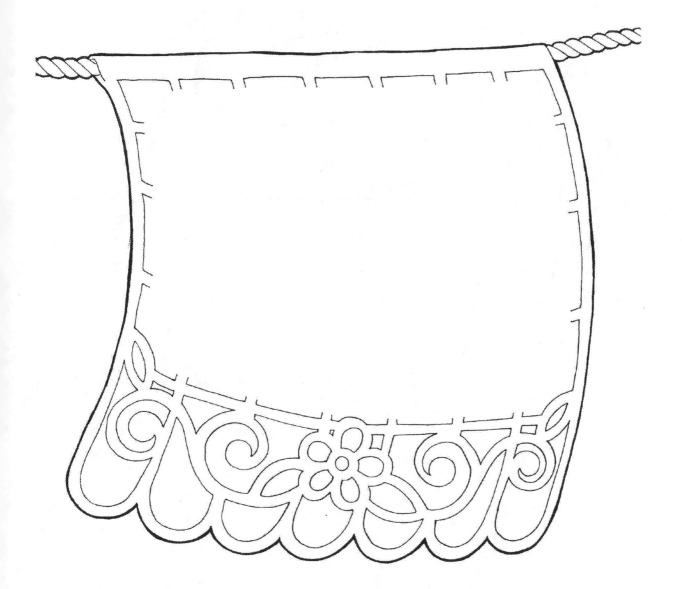

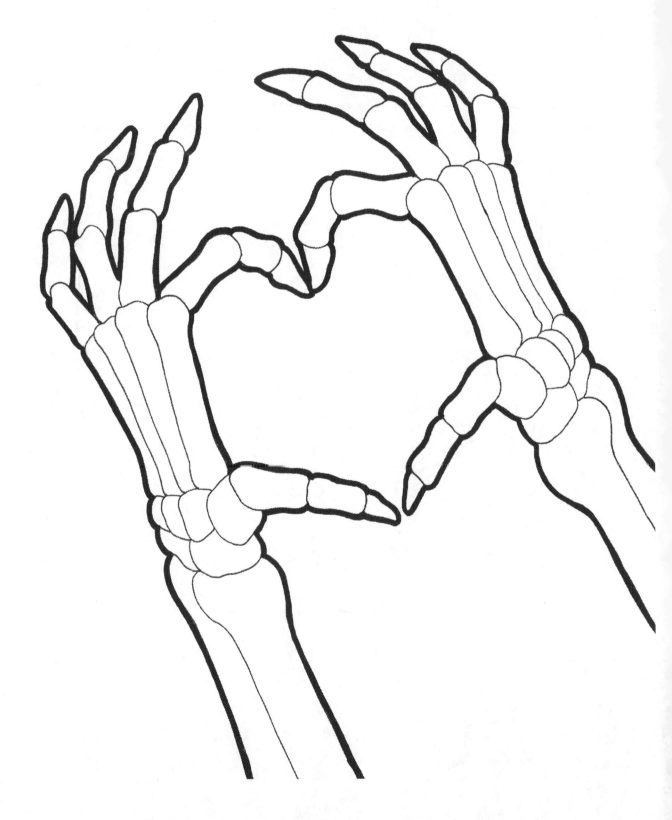

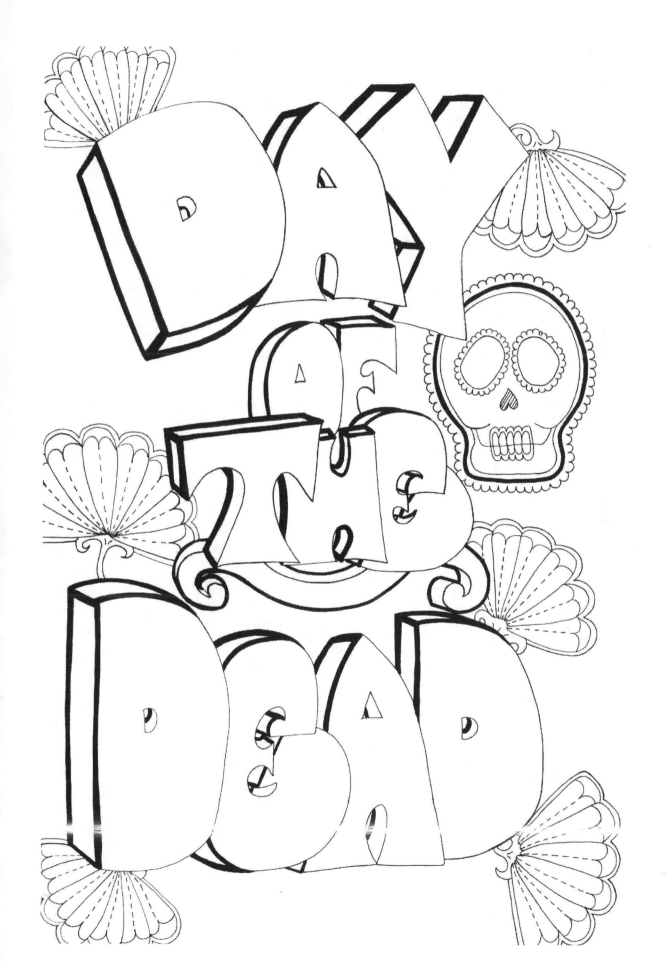

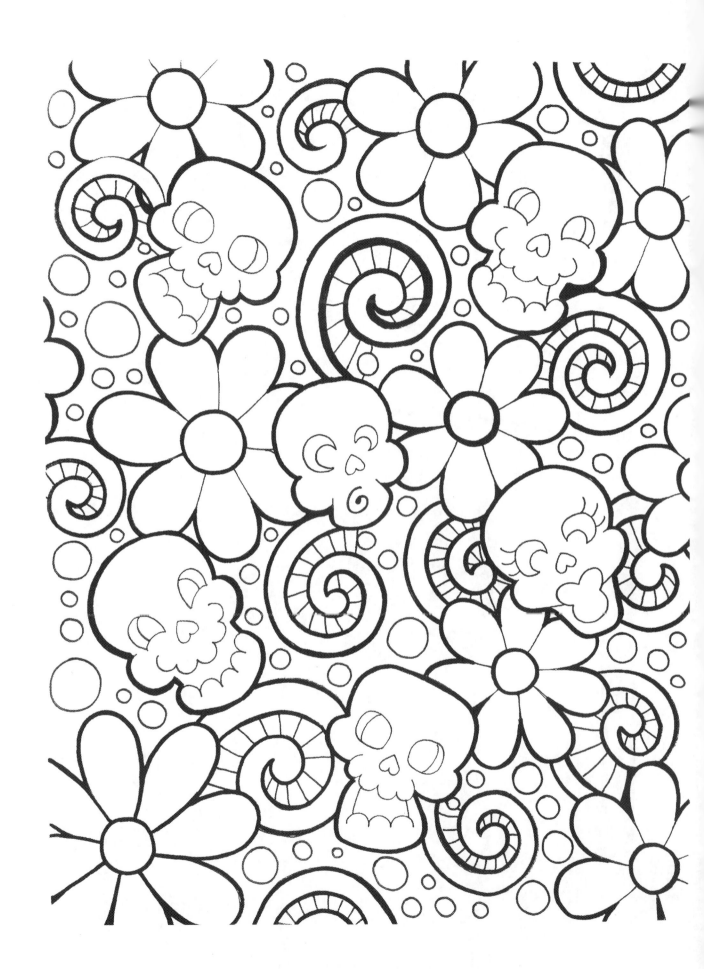